Deposit Collection	Date
Q39 Orchard	3/13
ML56	GH8
WG7	
MS1	29/9/16
A N5	PG5
J+9 JA9	
J84	

SPECIAL 000000957455

ISLAND LIGHT

JOHN SYLVESTER

NIMBUS
PUBLISHING

Nimbus Publishing Limited
PO Box 9166
Halifax, NS B3K 5M8
(902) 455-4286

Design: Kate Westphal, Graphic Detail
Charlottetown, PEI

Printed and bound in Canada

Canadian Cataloguing in Publication Data

Sylvester, John, 1955-
 Island Light

 ISBN 1-55109-363-4

 1. Landscape—Prince Edward Island—Pictorial works. 2. Natural history—Prince Edward Island—Pictorial works. 3. Prince Edward Island—Pictorial works. I. Title.

FC2612.S94 2001 508.717'022'2
C2001-900111-8 F1047.8.S94 2001

Canadä The Canada Council | Le Conseil des Arts
 for the Arts | du Canada

We acknowledge the financial support of the Government of Canada through the Book Publishing Industry Development Program (BPIDP) and the Canada Council for our publishing activities.

FACING PAGE: GREENWICH. THIS HUGE PARABOLIC DUNE—THE ONLY ONE OF ITS KIND IN PRINCE EDWARD ISLAND—IS ONE OF THE CENTRAL FEATURES OF THE GREENWICH PENINSULA.

ACKNOWLEDGEMENTS

Thanks to Laurie Brinklow for her editorial assistance, and to the good people at Tourism PEI and Prince Edward Island National Park.

A very special thanks to my wife Dianne, for her love and support.

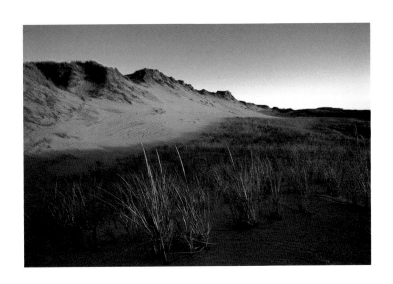

FOR MY PARENTS, GEORGE AND MARILYN SYLVESTER,
WITH LOVE.

PRINCE EDWARD ISLAND

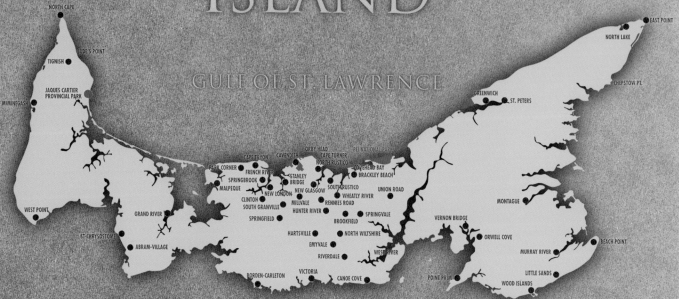

GULF OF ST. LAWRENCE

NORTH CAPE
JUDE'S POINT
TIGNISH
JAQUES CARTIER PROVINCIAL PARK
MIMINEGASH
WEST POINT
ST-CHRYSOSTOME
ABRAM-VILLAGE
GRAND RIVER
PARK CORNER
SPRINGBROOK
MALPEQUE
CLINTON
SOUTH GRANVILLE
SPRINGFIELD
HARTSVILLE
EMYVALE
RIVERDALE
BORDEN-CARLETON
VICTORIA
CANOE COVE
FRENCH RIVER
CAPE TRYON
CAVENDISH
STANLEY BRIDGE
NEW LONDON
NEW GLASGOW
MILLVALE
HUNTER RIVER
ORBY HEAD
CAPE TURNER
NORTH RUSTICO
SOUTH RUSTICO
WHEATLY RIVER
RENNIES ROAD
BROOKFIELD
NORTH WILTSHIRE
WEST RIVER
PEI NATIONAL PARK
COVEHEAD BAY
BRACKLEY BEACH
UNION ROAD
SPRINGVALE
VERNON BRIDGE
ORWELL COVE
POINT PRIM
GREENWICH
ST. PETERS
CHEPSTOW PT.
EAST POINT
NORTH LAKE
MONTAGUE
MURRAY RIVER
LITTLE SANDS
WOOD ISLANDS
BEACH POINT

NORTHUMBERLAND STRAIT

I came to Prince Edward Island on a whim. Although I was born in neighbouring Nova Scotia, and had travelled extensively in the rest of the country, I had never been to Canada's smallest province. So, while touring the Atlantic region in the summer of 1982, I decided it was time to have a look. On a clear June evening I arrived by ferry (there was no bridge then!) to behold a gentle rural landscape in vivid hues of green, red, and blue. I had never seen anything like it before, and I knew immediately I wanted to live here.

I returned several times that summer to explore the Island from North Cape to East Point. I walked the North Shore beaches, swam in the Gulf of St. Lawrence, and ate whole quarts of strawberries purchased at roadside stands. But mainly I drove the endless network of roads, frequently losing my way, and stopping often to try and capture on film the colour and light of the Island.

In all my explorations, I found myself drawn back to the area of central Queen's County near Wheatley River — a gently rolling landscape dotted with tidy farmsteads, pastures of grazing cattle, and alternating fields of hay, grain, and woodland that stretch down to the winding Wheatley River. I thought that if I were to live in Prince Edward Island, this is where I would like to be.

Little did I realize that I would soon be living there, in a house that my wife and I built together on a hill overlooking a hollow, through which runs a small tributary of the Wheatley River. As I write I look out my window at the now familiar landscape of forest and field in its muted late October colours.

Many of the images in this book were made within a few kilometres of my doorstep in this landscape that has become my "neighbourhood." In fact one of the images was actually made from my doorstep! So I am indeed privileged to live surrounded by such beauty and inspiration.

"Islands," I've heard it said, "are geographically perfect." Their boundaries are precisely defined by nature, not by lines drawn arbitrarily on a map. For the photographer, Prince Edward Island may be just a little more perfect than others. It not only catches the magical light of sunrise and sunset, but from the air it resembles a giant patchwork quilt: red corduroy potato fields, green velvet pastures, and plush fields of grain all stitched together with the dark green thread of spruce hedgerows. The edges of the quilt are frayed, eroded red cliffs that give way to long strands of beach and dunes that stretch across shallow bays on the Island's North Shore.

It is a landscape that has been profoundly changed by human activity. Four hundred years ago, Prince Edward Island was almost completely covered by Acadian forest, which included maple, beech, ash, white pine, and red oak. There were no permanent residents. The aboriginal population in the area, the Mi'kmaq, lived on the mainland, and, like present-day tourists, visited the Island only in summer. They fished, gathered clams and other shellfish, and hunted for wildfowl, seals, and whales.

It was with the arrival of the European settlers in the early 1700s that land clearing began in earnest. During the next 160 years, French, English, Scottish, and Irish settlers transformed the Island from a forested wilderness into a prosperous rural society of 100,000 people engaged in farming, fishing, and shipbuilding. By the late 1800s, the Island landscape had acquired the distinctive patchwork appearance that it still retains today. Agriculture continues to be the number one economic activity in the province, and, although tourism has overtaken fishing as the second most important activity, it is farming and fishing that shape the Island's unique rural character.

Wilderness was pushed out to the edges, and to some extent it can still be found there in the off-

shore islands, salt marshes, and sand dunes along the province's North Shore. Although these wild areas make up only a tiny percentage of the land mass, their contribution to the uniqueness and appeal of the Island landscape is undeniable. The sand dunes in Prince Edward Island National Park, especially the spectacular sand hills at Greenwich, are unequalled anywhere.

Every season has its appeal in Prince Edward Island, although I have to admit you would be hard pressed to find the attraction in a reluctant Island spring. The icy grip of surrounding pack ice in the Gulf of St. Lawrence and Northumberland Strait causes Island winters to linger long into April and May. I have even seen ice in the Strait in June! So the long-anticipated summer is much cherished by Island residents. When it finally arrives, the province springs to life with activity — farmers on the land, fishermen on the water, and tourists on the roads.

The arrival of summer always brings a renewed sense of energy and inspiration, and marks the beginning of my photography season. There is nothing I like better than to set out from my home just before sunrise on a clear June morning to make photographs in the surrounding countryside. The days are long at this time of year, so it is indeed very early when I set out, even before most farmers are awake. I have the Island to myself. The weather conditions of the day will determine my direction. If the wind is calm and there is mist in the hollow, my first stop might be the Wheatley River bridge, where, if I am lucky, I will photograph the mirror-perfect reflection of the village in the diffused light of morning.

If there is no mist in the hollow and a wind ripples the surface of the river, I will set out for the North Shore. In the village of North Rustico, fishermen will be heading out of the harbour to check their traps in the Gulf of St. Lawrence. I'll set my

tripod up on the end of the breakwater and photograph the boats as they motor past against a shimmering sunrise. When the last boat has disappeared over the horizon, I'll continue west along the shore to Cape Turner or Cavendish in Prince Edward Island National Park. In the early morning light the sandstone cliffs turn a brilliant red, contrasting dramatically with the many shades of blue in the surrounding water and sky.

Late June is also when lupins appear along Island roadsides, tall blossoms of purple and pink spilling down through the ditches and into overgrown fields. I have spent many happy hours completely absorbed in my efforts to capture their beauty on film. They are just the first of the roadside flowers by which you can mark summer's progress; July brings daisies, sweet clover, fireweed, and Brown-eyed Susans. Queen Anne's lace and goldenrod announce summer's end in late August and early September.

The agricultural landscape changes dramatically through the short growing season. Within just a few weeks, red dirt rows of newly planted potatoes are transformed into a carpet of green leaves sprinkled with white blossoms. Changes also take place from one year to the next. Most farmers rotate their crops over three years, so one summer I might photograph the neat rows of a potato field, the next will be swathes of grain, followed in the third by round bales of hay. In some of my favourite locations I keep track of the crop rotation so I can predict roughly when the field is at its best for photography. So while the overall design of this patchwork landscape remains much the same, the details are constantly being altered.

When the harvest begins in early September, I briefly turn my attention back to the Island's edges. Autumn winds will have blown the footprints of summer from the beaches and dunes, returning this

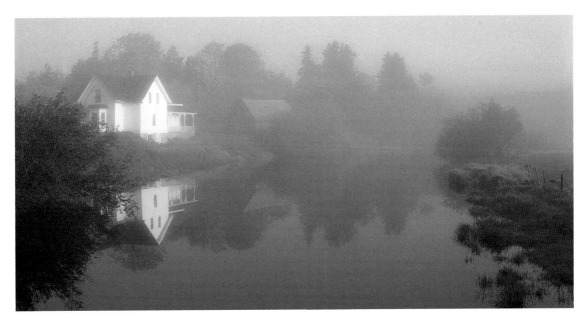

WHEATLEY RIVER

extraordinary environment to its wild and pristine state. I'll wander through the dunes — taking care not to step on the fragile marram grass — to photograph the remarkable variety of sand patterns. A few years ago I arrived at one of my favourite locations on a cold autumn morning to discover the dunes sheathed in a layer of sparkling white frost. I spent an hour completely immersed in this entrancing world before the morning sun melted it away.

As fall progresses, again I'll turn inland to photograph the changing colours of the autumn landscape. My eye is drawn away from the now subdued fields of plowed red soil and pale fields of straw to the colourful tapestry of red and gold appearing in the adjacent woodland. In many parts of the Island old clay roads — some designated as "heritage" roads — wind their way through tunnels of overhanging leaves.

Winter arrives late on Prince Edward Island, often not really setting in until the sea ice forms in January. It's a challenging season for photography. Snow rarely drifts to the ground, but rather is driven horizontally by northeasterly gales. The moments of magic are often fleeting — a "silver freeze" of frost-covered trees, snow-drifted fields after a blizzard, or the glittering aftermath of an ice storm — and I know I must try to capture them quickly before a winter thaw or the wind sweeps them away.

What follows is a selection of these captured moments in all seasons. It is by no means a comprehensive guide to the Island, but rather my own personal photographic diary of a landscape that has held my imagination all these years. These images are a few of my favourites, the result of many attempts to record the magic and light of my adopted home.

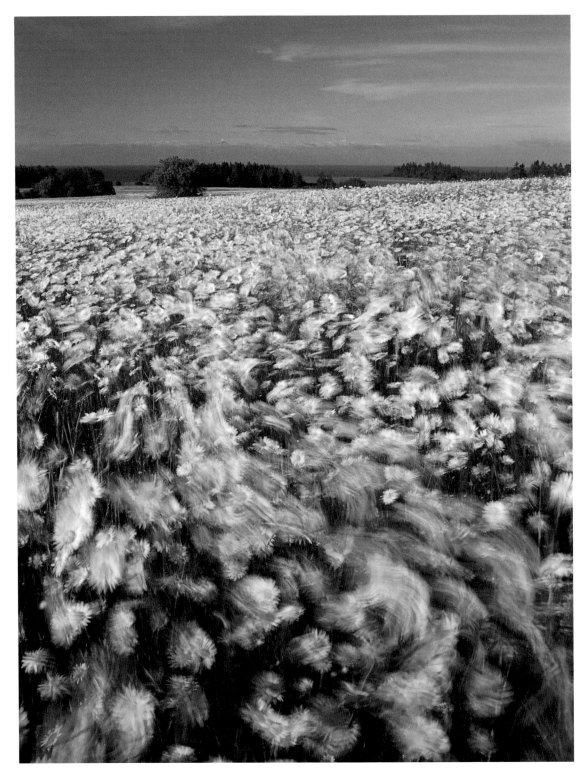

POINT PRIM. WIND IS OFTEN AN ADVERSARY WHEN PHOTOGRAPHING ON THE ISLAND.
BUT HERE, IN A FIELD OF DAISIES, I LET THE WIND CREATE THIS IMPRESSIONISTIC IMAGE.

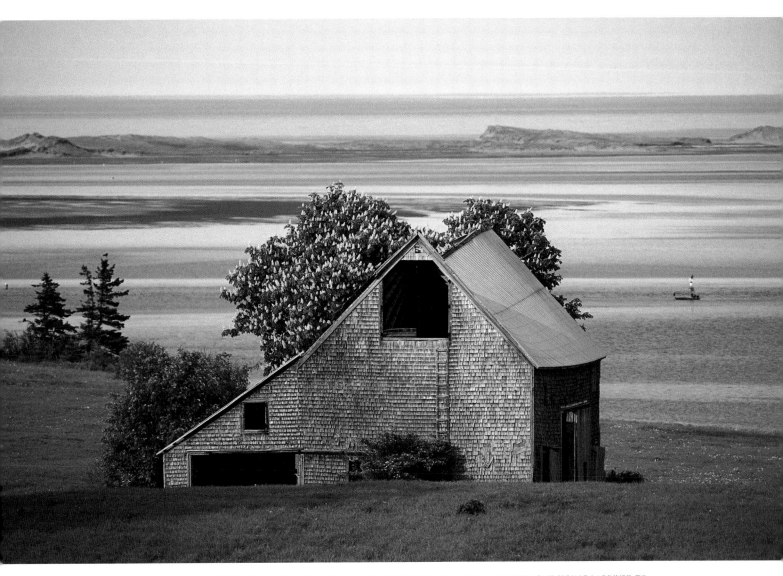

SPRINGBROOK. I PHOTOGRAPHED THIS OLD BARN AND CHESTNUT TREE FOR MANY YEARS. THEN ONE SPRING I ARRIVED TO
DISCOVER THEY HAD VANISHED WITHOUT A TRACE. SHORTLY THEREAFTER A SUMMER HOME WAS BUILT IN THEIR PLACE—A
STARTLING REMINDER OF HOW THE ISLAND IS CHANGING.

OVERLEAF: VERNON BRIDGE. FARMING SHAPES THE TEXTURE OF THE ISLAND LANDSCAPE. ROWS OF NEWLY PLANTED POTATOES
CAPTURE THE WARM LIGHT OF A JUNE EVENING.

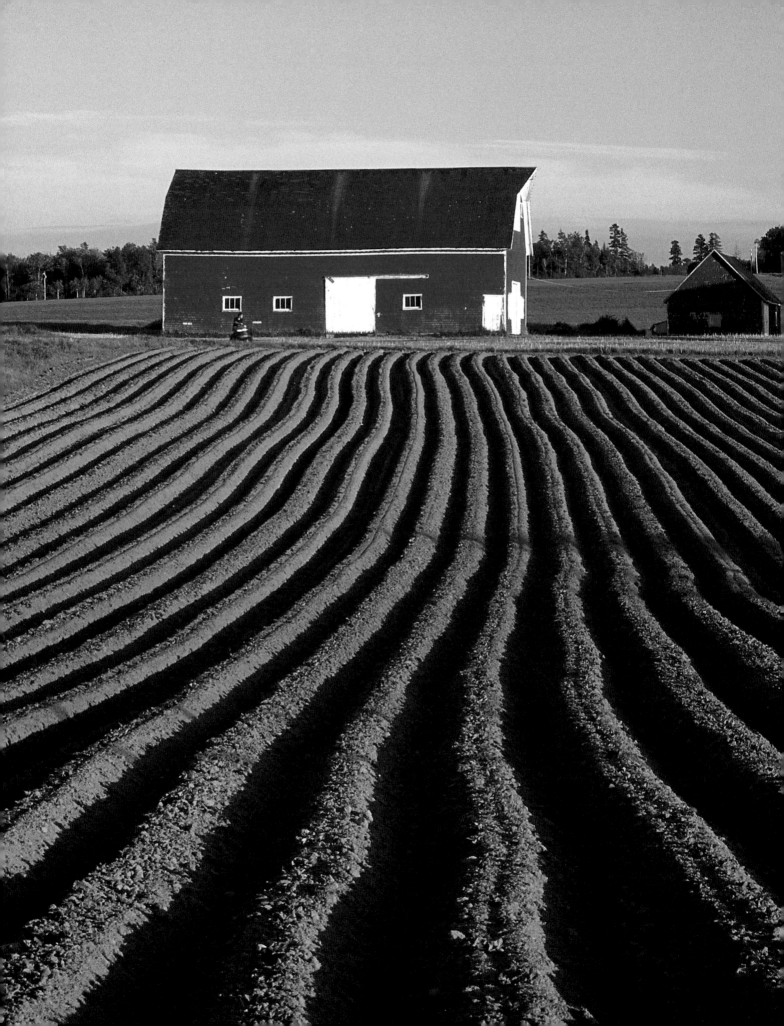

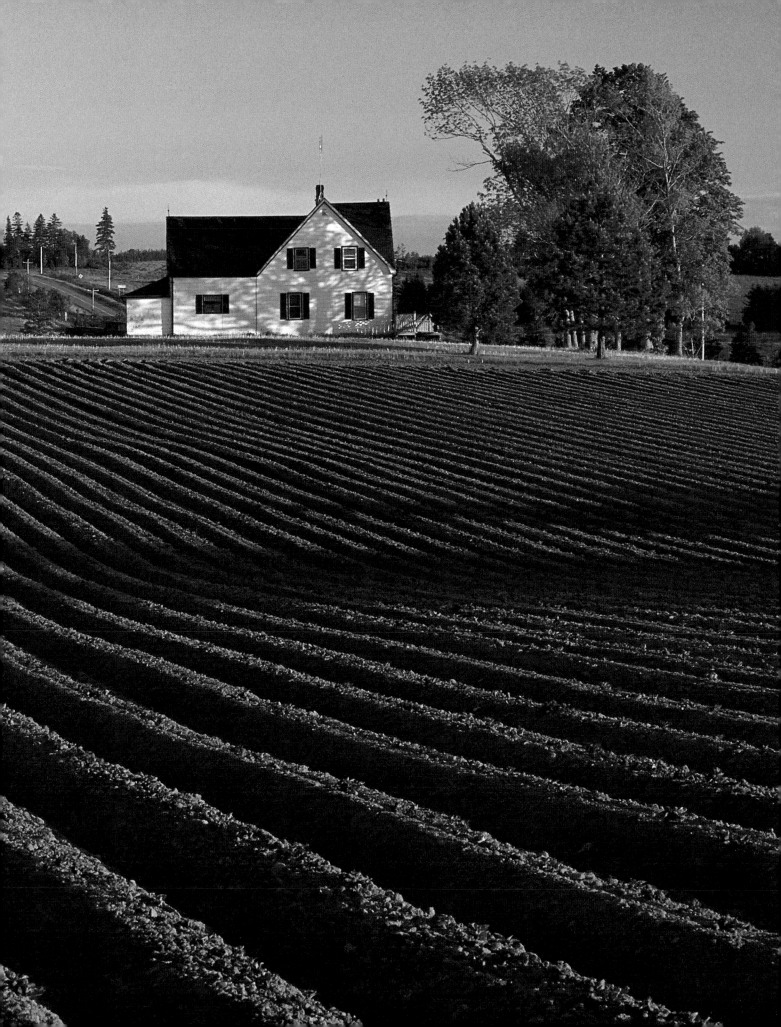

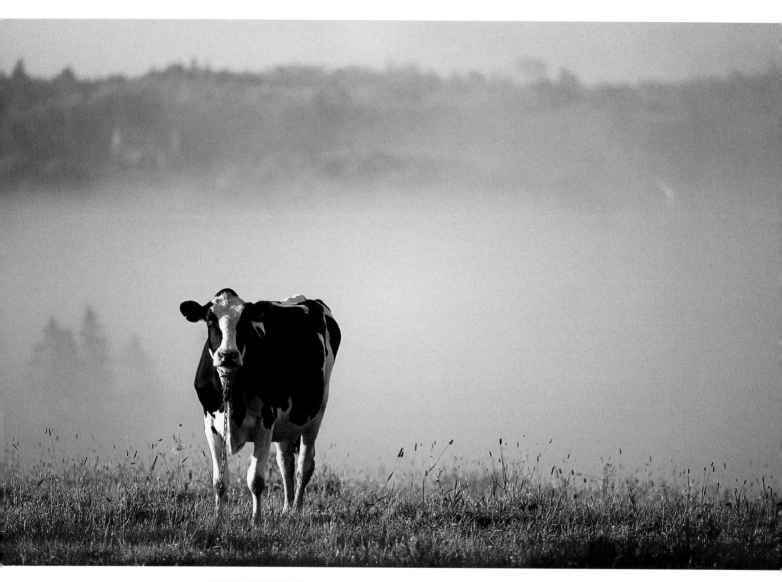

NEW GLASGOW. BY WANDERING OVER TO TAKE A CLOSER LOOK AT ME, A CURIOUS COW
OFFERS A SCENE DIFFERENT FROM THE ONE I WAS ATTEMPTING TO CAPTURE.

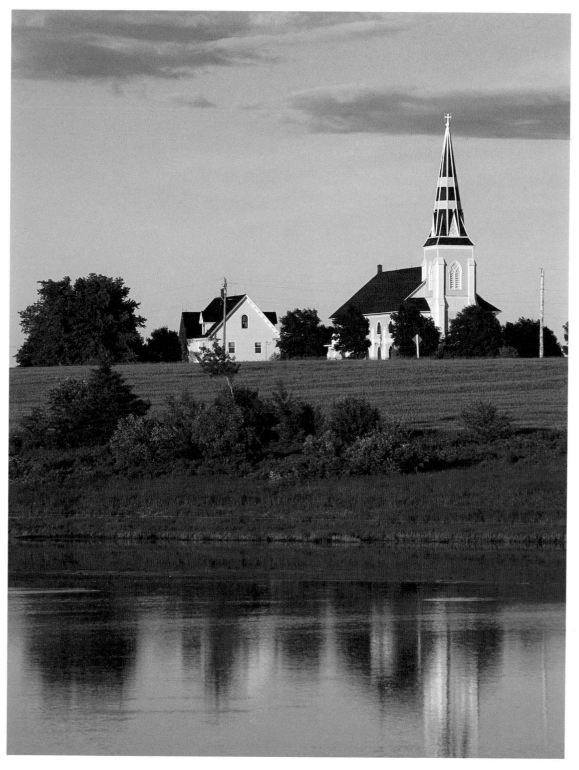

GRAND RIVER. THE ISLAND IS NOTED FOR ITS CHARMING WOODEN CHURCHES. FEW HAVE AS BEAUTIFUL
A SETTING AS ST. PATRICK'S ROMAN CATHOLIC CHURCH, OVERLOOKING THE GRAND RIVER.

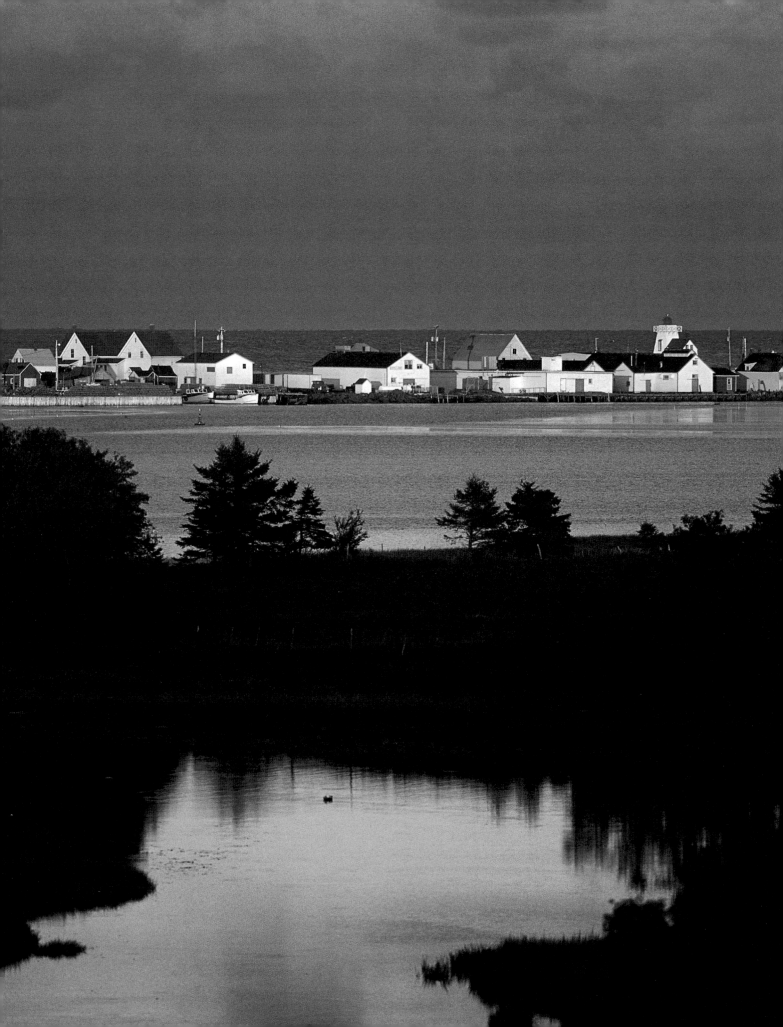

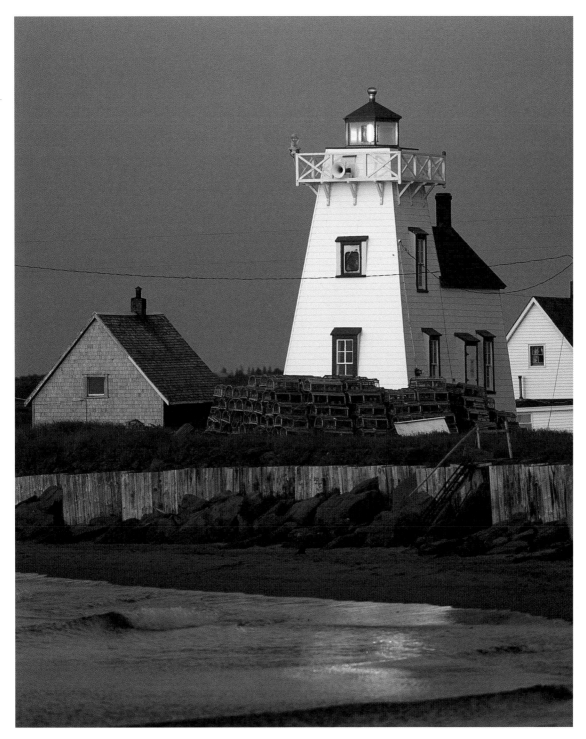

NORTH RUSTICO LIGHTHOUSE. EARLY ON A SPRING MORNING, I'LL POSITION MYSELF AT THE END OF THE NORTH RUSTICO
BREAKWATER TO PHOTOGRAPH THE FISHING BOATS AS THEY MOTOR PAST ON THEIR WAY TO THE FISHING GROUNDS.
BETWEEN BOATS, I MADE THIS IMAGE OF THE LIGHTHOUSE, WHICH STANDS AT THE HARBOUR ENTRANCE.

FACING PAGE: SUNLIGHT BREAKS THROUGH SUMMER RAIN CLOUDS TO HIGHLIGHT THE FISHING VILLAGE OF NORTH RUSTICO.

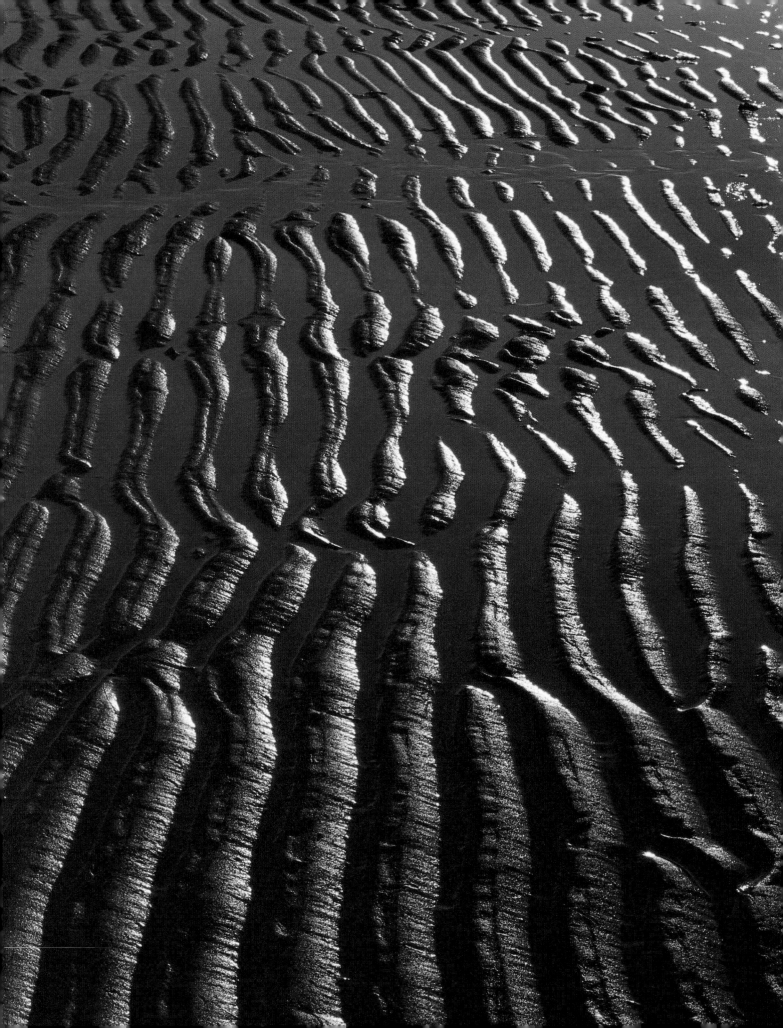

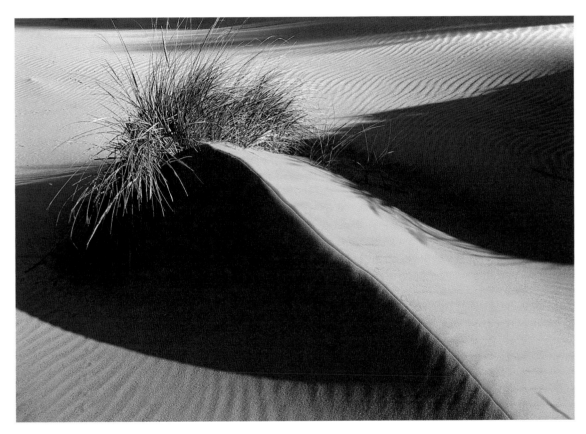

BRACKLEY BEACH. ONE MORNING IN OCTOBER I ARRIVED AT THIS LOCATION TO DISCOVER THE DUNES COVERED IN A LAYER OF
SPARKLING FROST. I WORKED FERVENTLY TO CAPTURE THE UNUSUAL SCENE BEFORE IT MELTED AWAY IN THE MORNING SUN.

FACING PAGE: BRACKLEY BEACH. WIND AND WAVES CONTINUALLY WORK VISUAL MAGIC IN THE
SHIFTING SANDS OF THE ISLAND'S BEACHES AND DUNES.

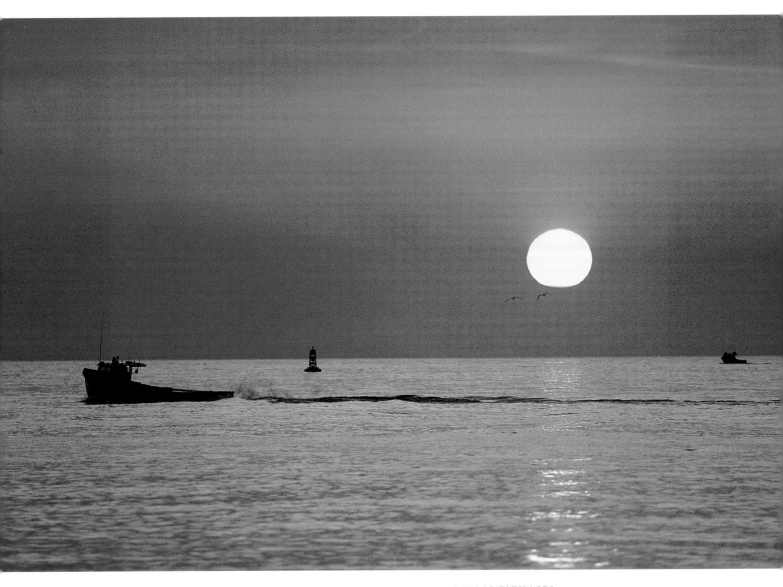

NORTH RUSTICO. AT SUNRISE. LOBSTER FISHERS STEER THEIR BOATS TOWARDS
THE HORIZON TO CHECK THEIR TRAPS IN THE GULF OF ST. LAWRENCE.

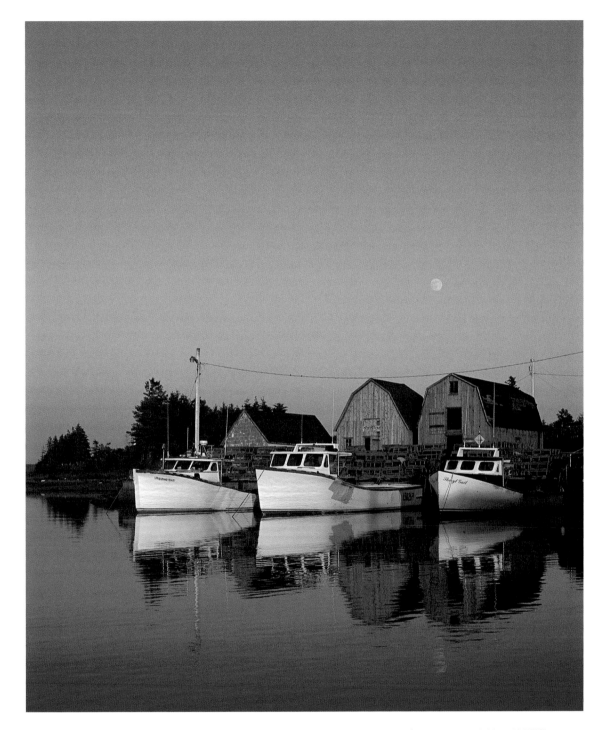

FRENCH RIVER. THE LOBSTER FISHERY IS THE ECONOMIC MAINSTAY OF THE ISLAND'S MANY FISHING COMMUNITIES.
THERE ARE TWO SEASONS: THE SPRING SEASON IN MAY AND JUNE IN THE GULF OF ST. LAWRENCE, AND THE FALL
SEASON FROM MID-AUGUST TIL EARLY OCTOBER IN NORTHUMBERLAND STRAIT.

OVERLEAF: PARK CORNER. MID-SUMMER FIELDS OF GRAIN AND HAY ROLL DOWN TO THE DUNE-EDGED SHORE. ISLAND AUTHOR
L. M. MONTGOMERY WAS MARRIED IN PARK CORNER AND DREW INSPIRATION FOR HER WRITINGS FROM THIS LANDSCAPE.

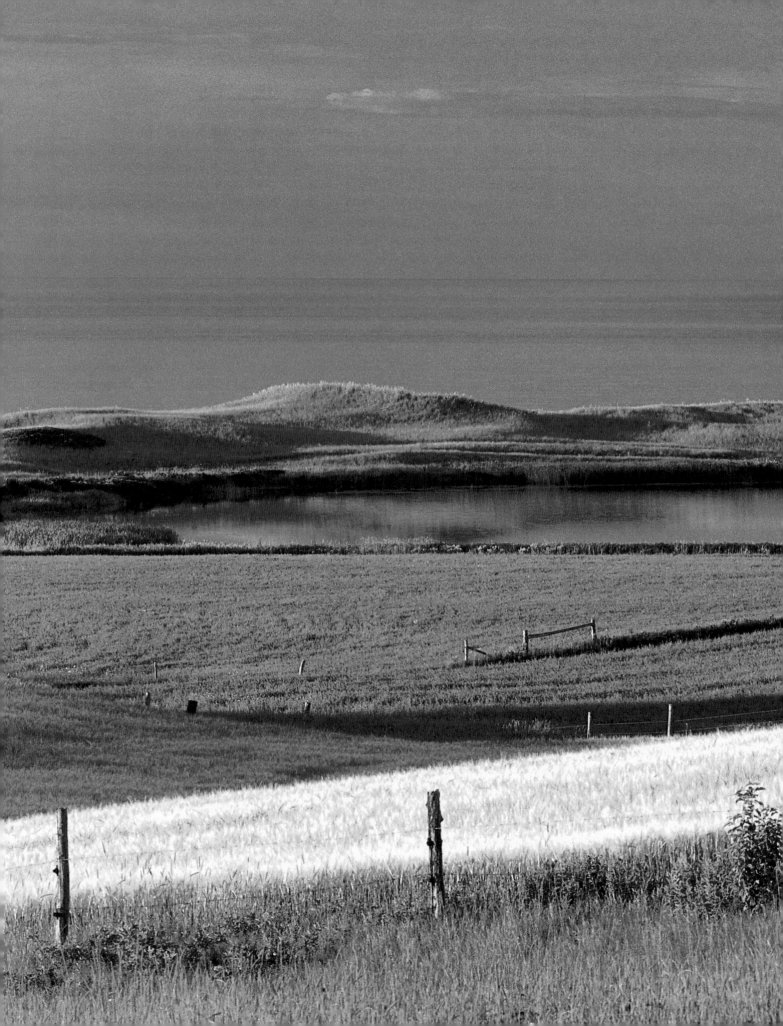

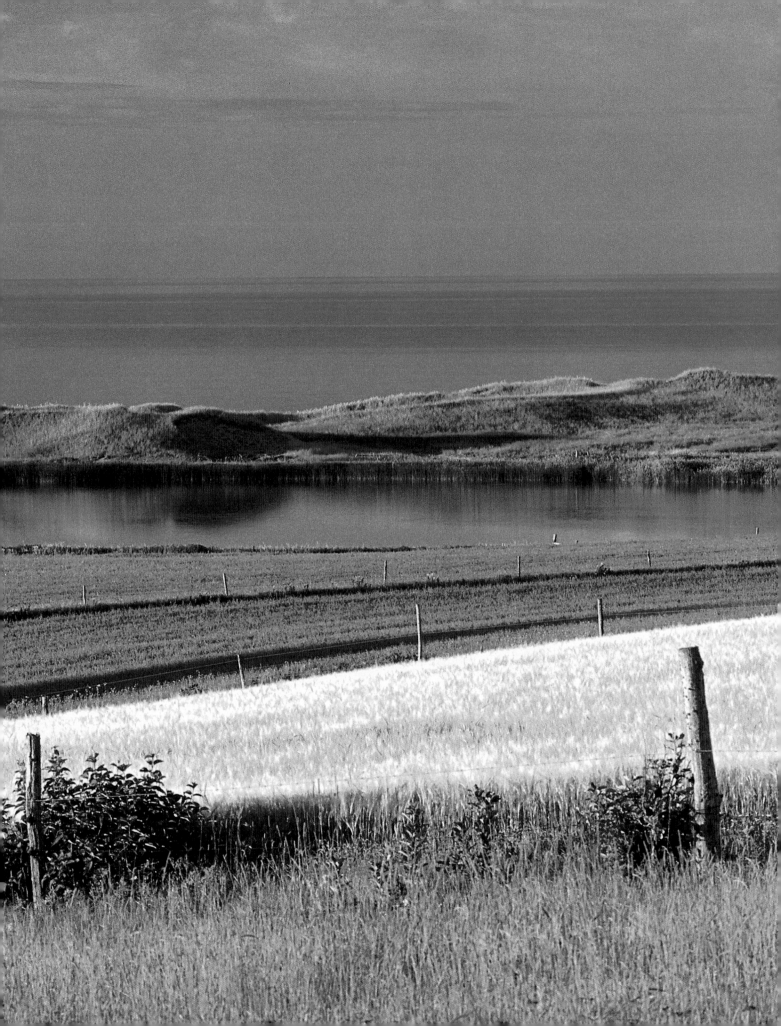

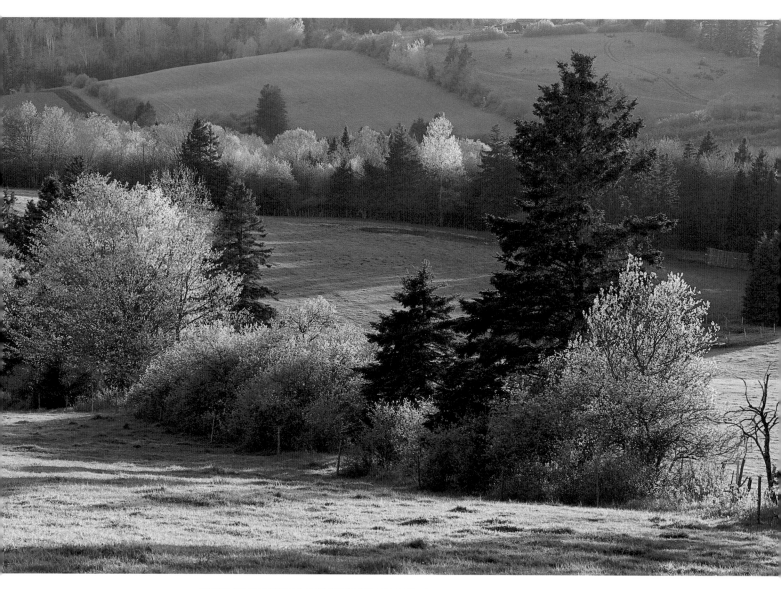

RIVERDALE. THE BRILLIANT GREEN OF NEW GROWTH ON THE HEDGEROWS AND FIELDS OF
CENTRAL QUEEN'S COUNTY SIGNALS THE BEGINNING OF THE LONG-AWAITED ISLAND SPRING.

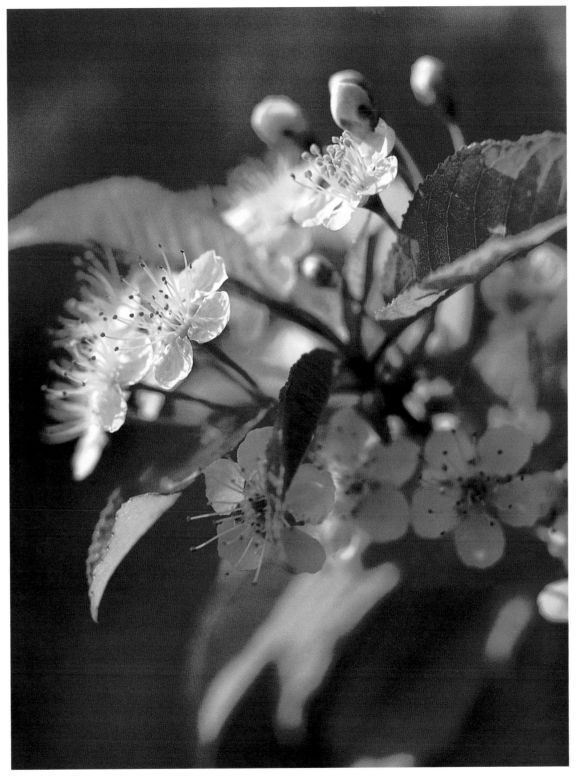

EMYVALE. SMALL, DELICATE BLOSSOMS OF THE PINCHERRY TREE BRING A SPRAY OF COLOUR TO ISLAND HEDGEROWS IN LATE MAY.

FRESHLY PAINTED LOBSTER TRAP BUOYS CAN BE FOUND IN EVERY ISLAND HARBOUR JUST BEFORE THE
FISHING SEASON OPENS. I'VE NOTICED THAT THE MOST COLOURFUL ONES ARE LOCATED IN THE WESTERN
END OF THE ISLAND, ESPECIALLY IN ST-CHRYSOSTOME, JUDE'S POINT, TIGNISH RUN, AND MIMINEGASH.

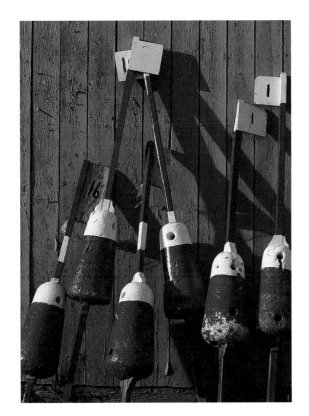

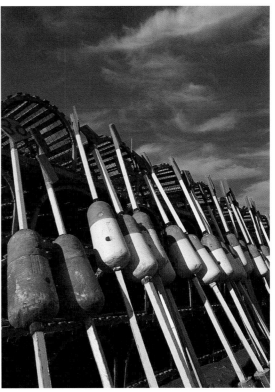

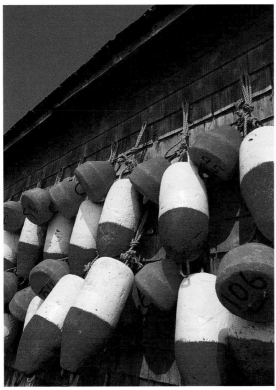

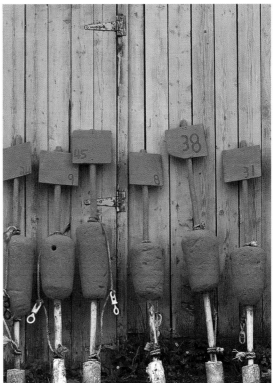

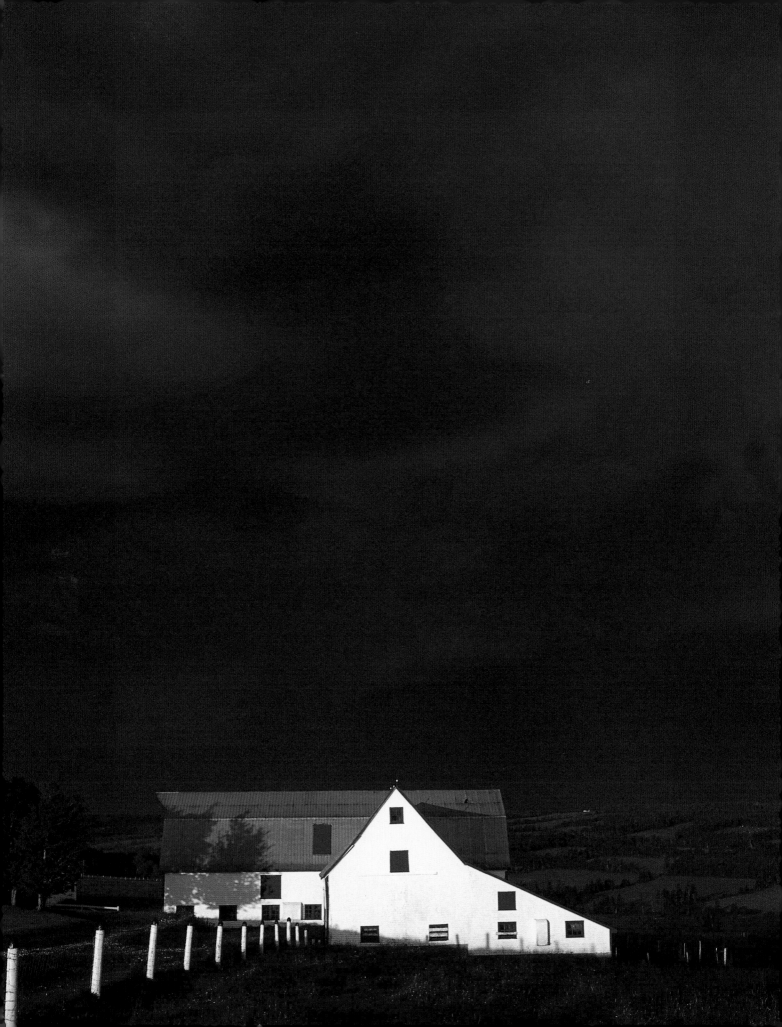

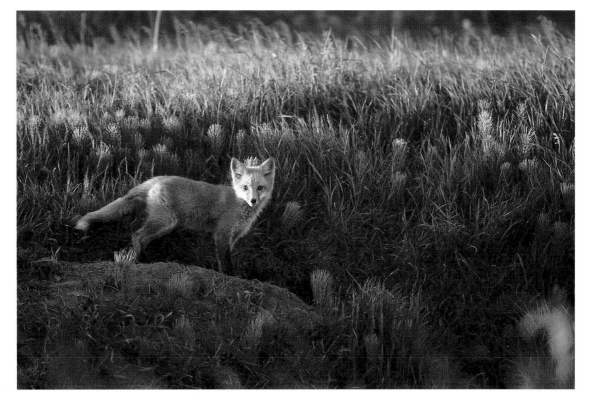

CAPE TRYON. A YOUNG FOX STANDS ALERT OUTSIDE ITS DEN ABOVE THE CLIFFS AT CAPE TRYON. AFTER MAKING THIS IMAGE
I CONTINUED ON MY WAY ALONG THE CLIFFS AND TURNED TO DISCOVER THE CURIOUS FELLOW FOLLOWING ME!

FACING PAGE: WHEATLEY RIVER. WHEN A RARE MORNING THUNDERSTORM RUMBLED OVER MY HOME.
I VENTURED OUT IN TIME TO CAPTURE THIS FLEETING MOMENT .

OVERLEAF: CAVENDISH. SWIMMERS VENTURE INTO THE SHIMMERING WAVES OF THE GULF OF ST. LAWRENCE ON A SUMMER EVENING.

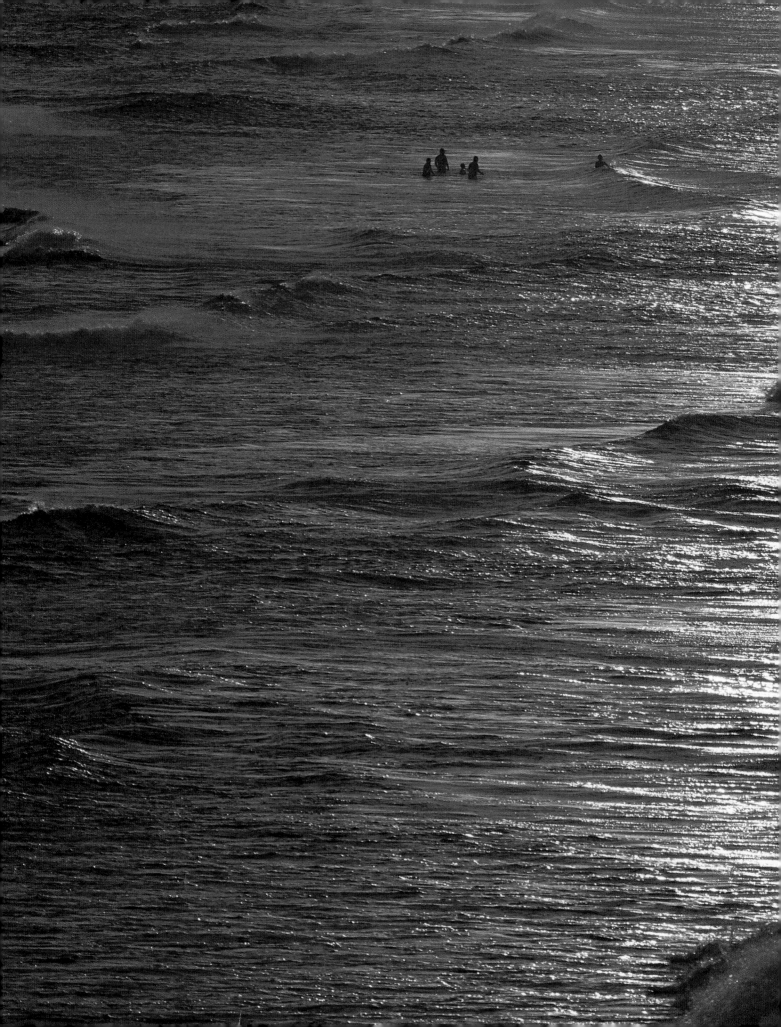

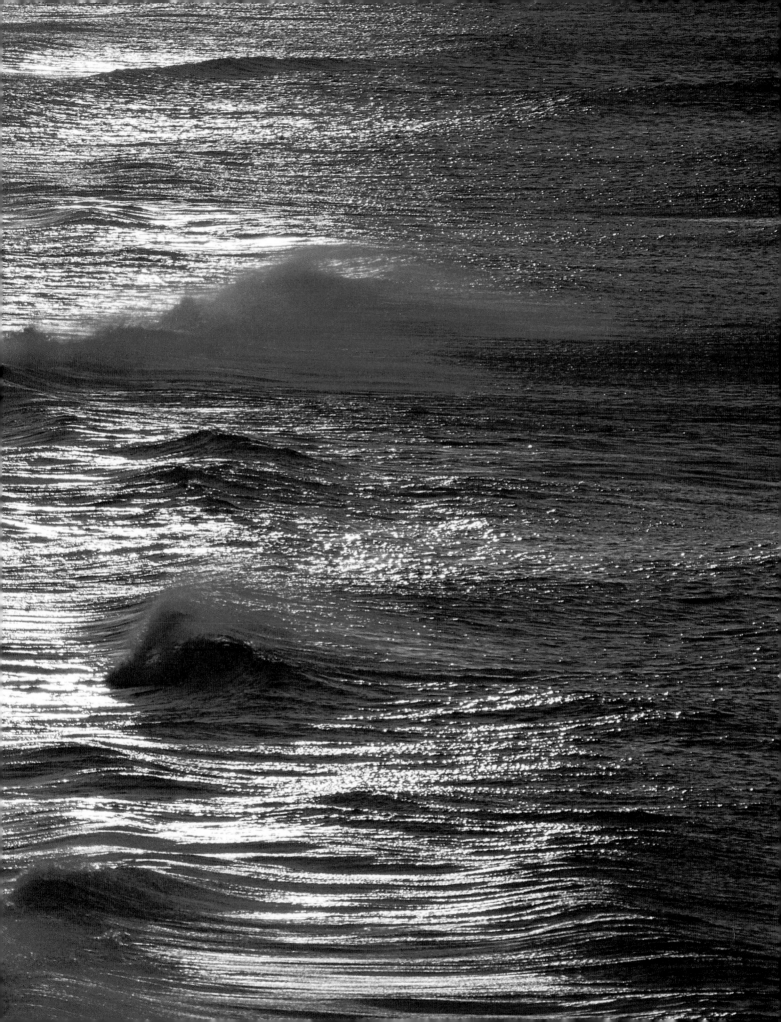

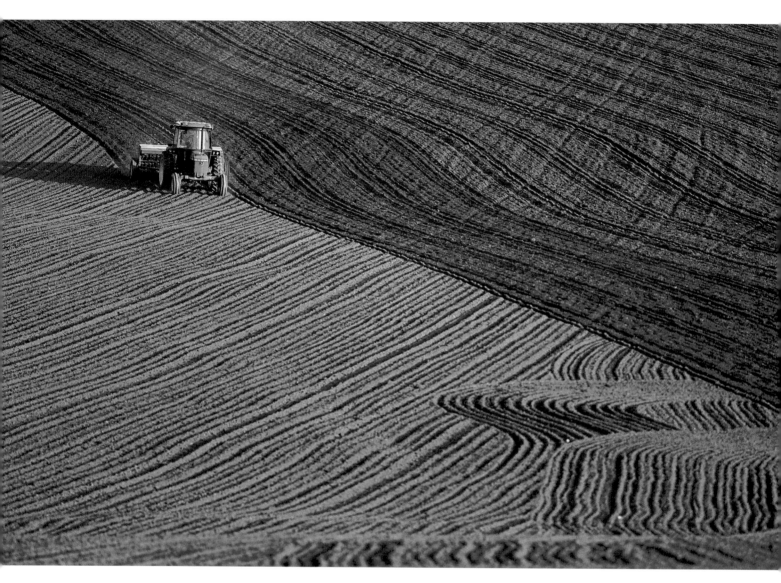

PARK CORNER. EVERY SPRING I LOOK FORWARD TO PHOTOGRAPHING THE PATTERNS CREATED
BY FARMERS WORKING THEIR FIELDS. HERE A FARMER SEEDS GRAIN INTO WELL-TILLED SOIL.

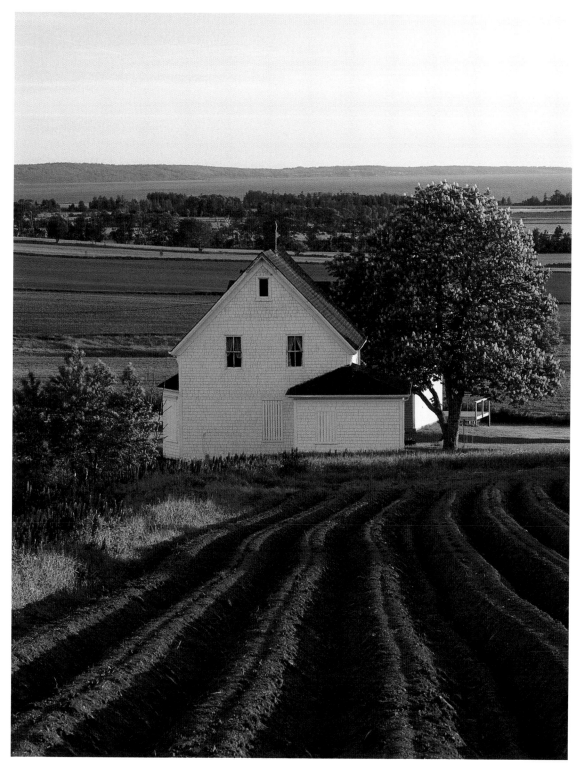

ORWELL COVE. I HAD PASSED THIS SCENE MANY TIMES OVER THE YEARS BEFORE REALLY NOTICING IT. FOR ME IT
BRINGS TOGETHER ALL THE ELEMENTS THAT MAKE JUNE SUCH A SPECIAL TIME OF YEAR ON THE ISLAND.

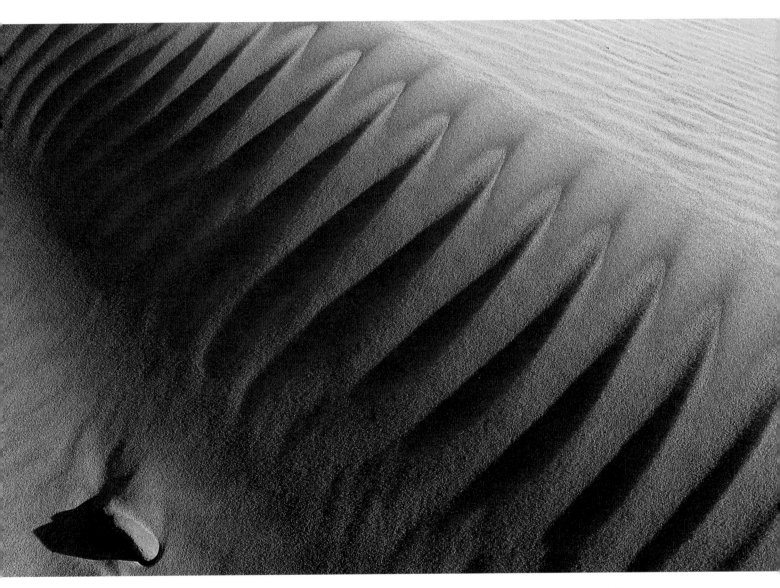

BRACKLEY BEACH. ON THE WIND-PATTERNED RIBS OF A DUNE, TRACES OF FROST MELT AWAY IN THE MORNING SUN.

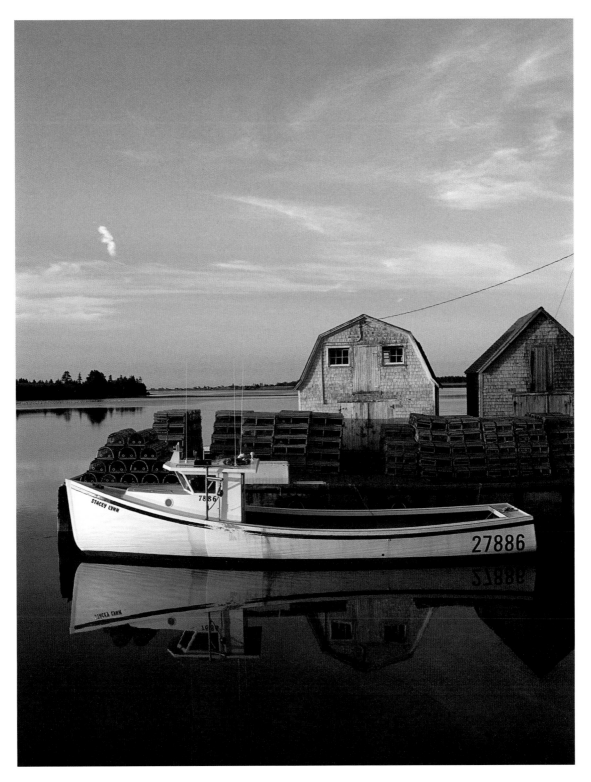

NEW LONDON. ON A TRANQUIL EVENING. BOATS TIED UP AND TRAPS STACKED
NEATLY ON THE WHARF MARK THE END OF LOBSTER SEASON IN EARLY JULY.

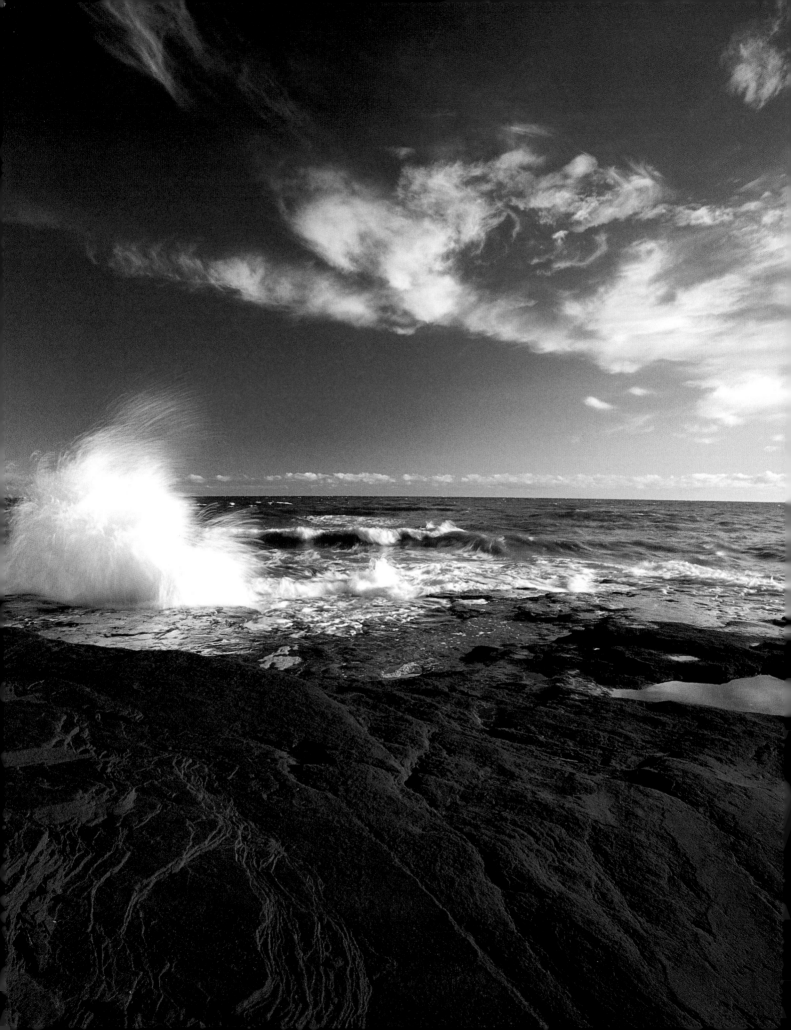

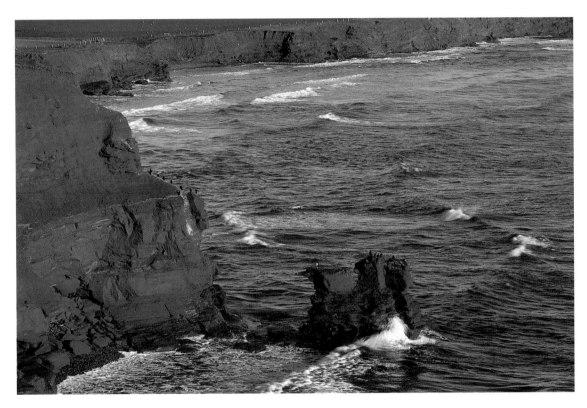

CAPE TRYON. THE FRAYED EDGES OF THE ISLAND—THESE SOFT RED SANDSTONE CLIFFS ARE CONTINUALLY BEING ERODED BY WAVES. THE DEBRIS WASHED FROM THE CLIFFS IS EVENTUALLY DEPOSITED ON THE ISLAND'S BEACHES AND SAND BARS.

FACING PAGE: CAVENDISH. A BREAKING WAVE EXPLODES AGAINST THE SHORE. PATIENCE AND LUCK HAD MUCH TO DO WITH THE CREATION OF THIS IMAGE. I MADE SEVERAL EXPOSURES, BUT ONLY IN THIS ONE DID ALL THE ELEMENTS COME TOGETHER TO CONVEY THE SCENE AS I ENVISIONED IT.

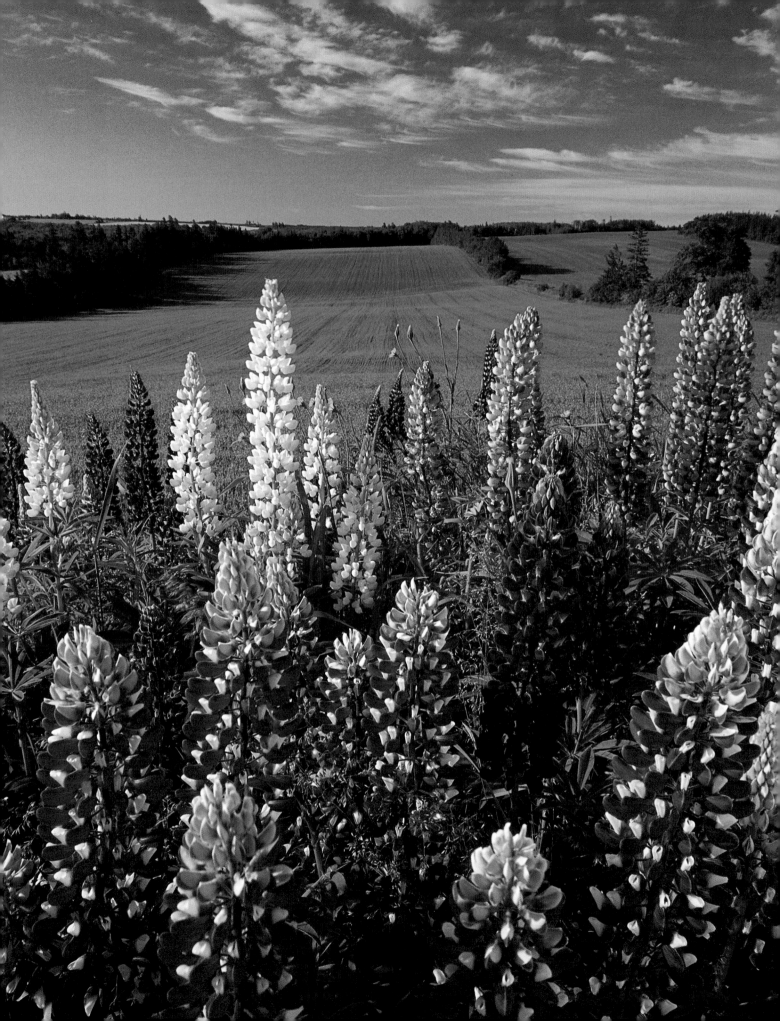

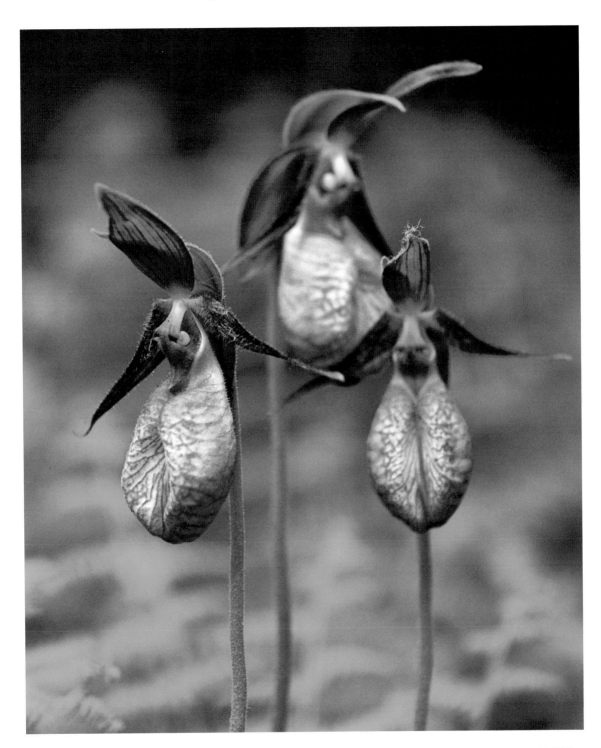

HARTSVILLE. EACH YEAR IN EARLY JUNE I RECEIVE A CALL FROM FRIENDS TO LET ME KNOW THAT "THE LADY'S SLIPPERS ARE OUT."
DOZENS OF PINK BLOSSOMS DOT THE FOREST FLOOR NEAR THEIR HOME. AS I WAS LEAVING, I MET TWO OF THEIR CHILDREN:
"I COUNTED ONE HUNDRED AND SEVENTY-THREE LADY'S SLIPPERS!" ONE OF THEM PROUDLY INFORMED ME.

FACING PAGE: CLINTON. SUMMER HAS ARRIVED WHEN THE ISLAND'S ROADSIDE DITCHES SPILL OVER WITH COLOURFUL LUPINS.

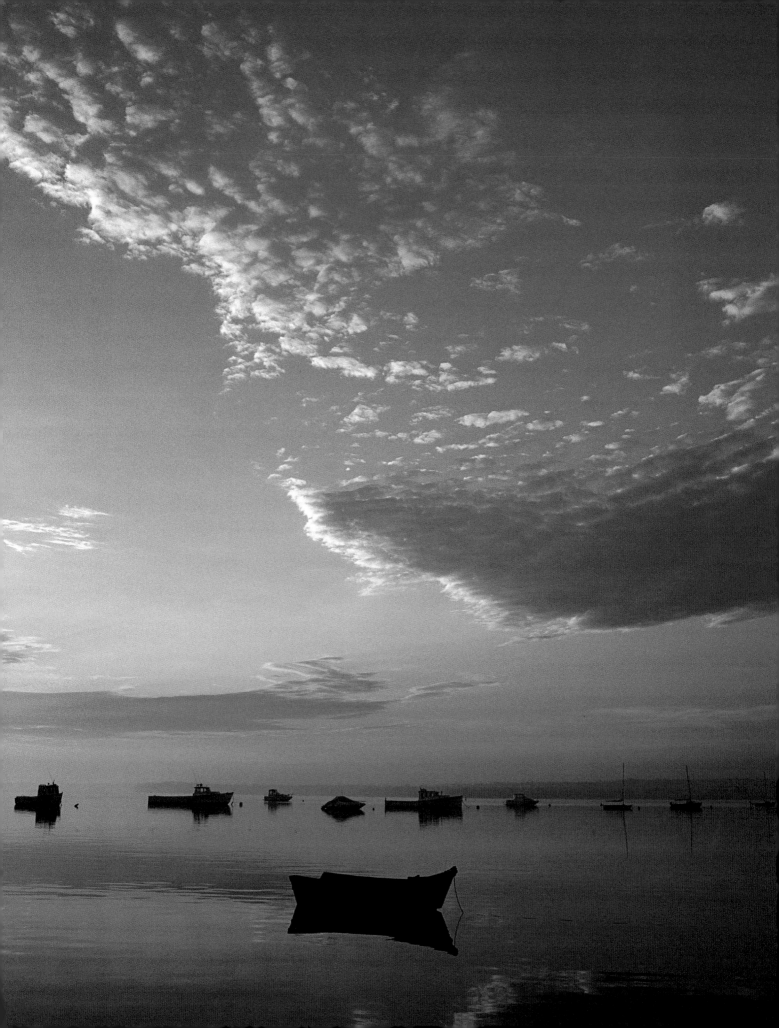

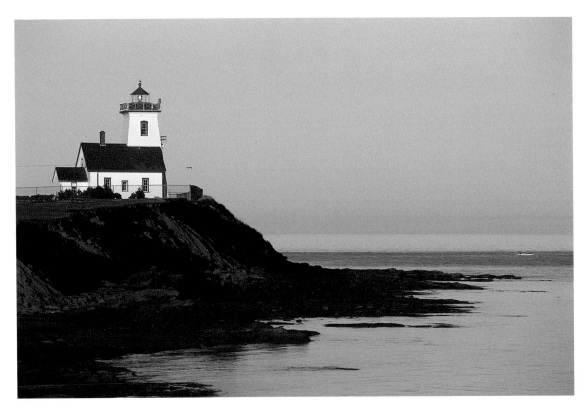

WOOD ISLANDS LIGHTHOUSE. THIS DISTINCTIVE LIGHTHOUSE, PERCHED ON A CLIFF OVERLOOKING NORTHUMBERLAND STRAIT, GREETS ALL VISITORS WHO TRAVEL TO THE ISLAND BY FERRY FROM NOVA SCOTIA.

FACING PAGE: WEST RIVER. ON A MID-SUMMER MORNING, A LONE OYSTER DORY IS SURROUNDED BY PLEASURE BOATS ON THE WEST RIVER. IN AUTUMN, THE SCENE IS REVERSED WHEN THE FISHING SEASON OPENS AND DOZENS OF OYSTER FISHERS CONVERGE ON THE RIVER WITH THEIR DORIES.

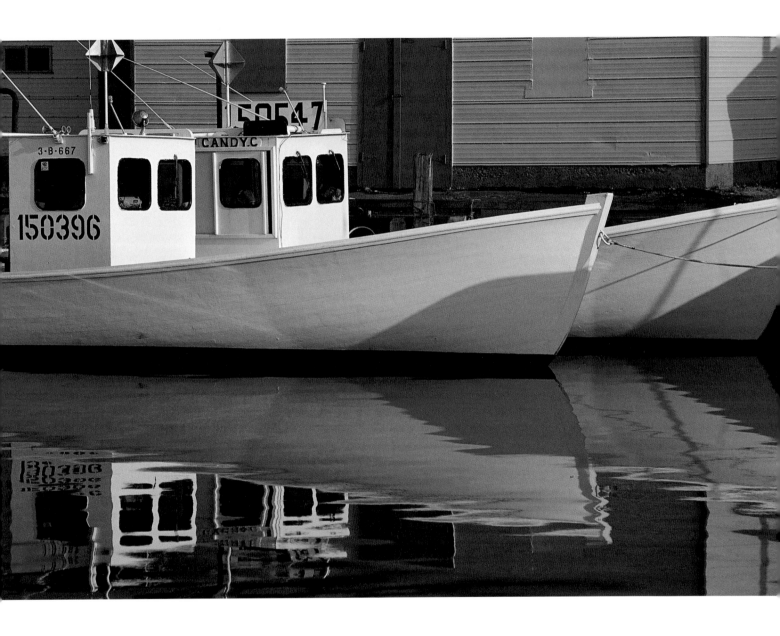

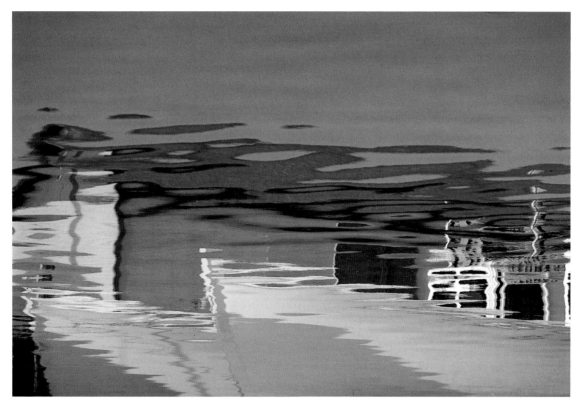

NORTH LAKE. THE BOLD COLOURS OF A FISH SHED AND DISTINCTIVE LINES OF THESE OLDER STYLE LOBSTER BOATS
CREATE A STRIKING REFLECTION IN NORTH LAKE HARBOUR. THE BOATS REMIND ME OF CHILDREN'S TOYS!

OVERLEAF: CAVENDISH. THE EASTERN END OF CAVENDISH BEACH IS A POPULAR SUMMER LOCATION FROM WHICH TO WATCH
SUNSETS. I USUALLY RESIST THE SUNSETS IN FAVOUR OF THE WARM EVENING LIGHT ON NEARBY CLIFFS. HOWEVER, THE DRAMATIC
SKY CREATED BY A RECEDING STORM COMPELLED ME TO CAPTURE THIS MOMENT.

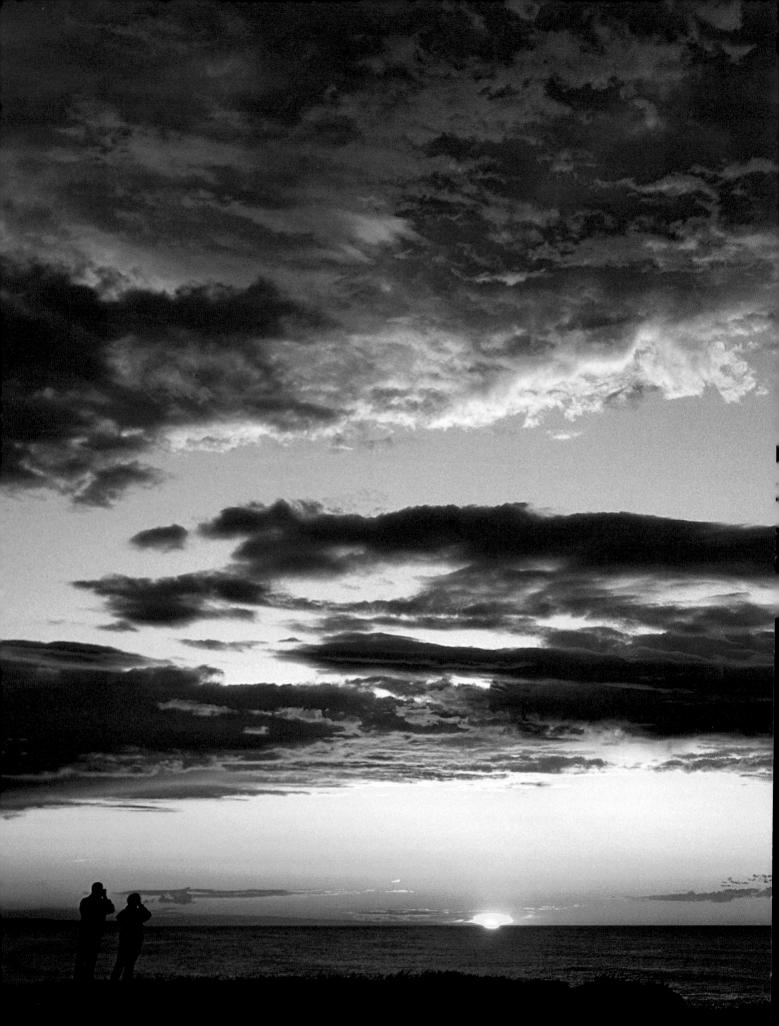

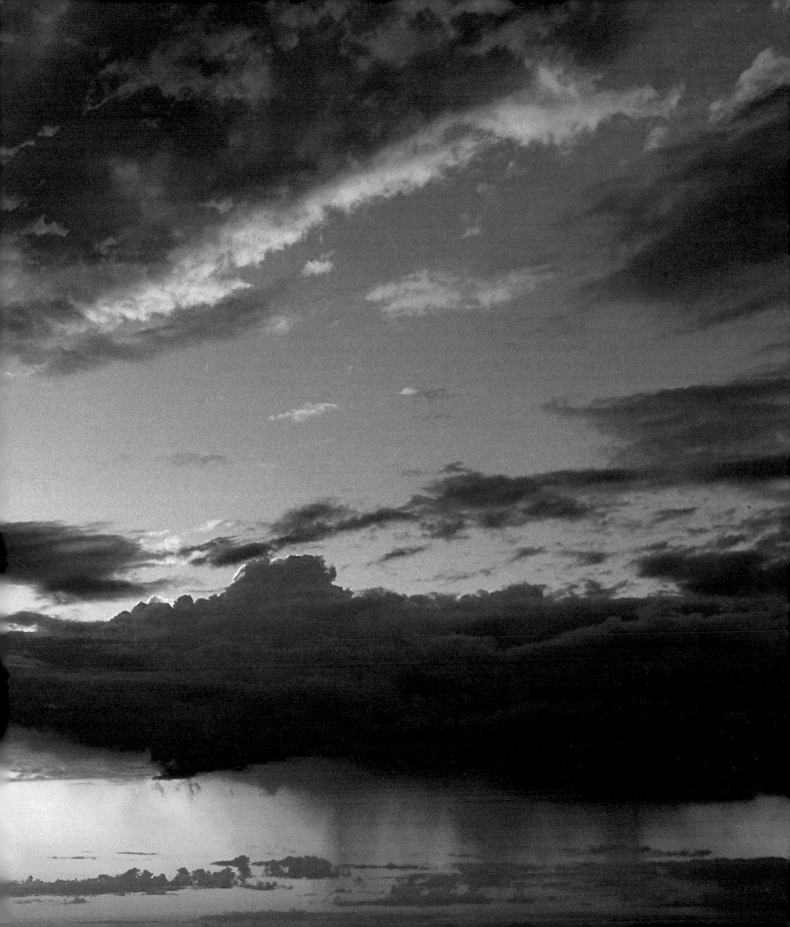

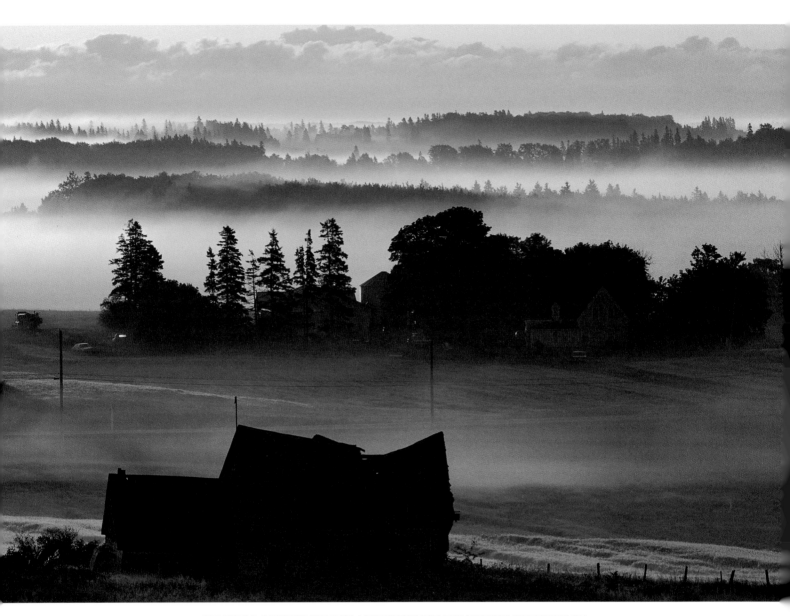

BROOKFIELD. ON MISTY MORNINGS, I USUALLY DRIVE TO THIS LOCATION TO PHOTOGRAPH
THE BACK-LIT LANDSCAPE AT SUNRISE. THE COLLAPSING HOUSE IN THE FOREGROUND IS A REMINDER
OF AN EARLIER ERA WHEN THERE WAS A FARMHOUSE ON EVERY FIFTY ACRES.

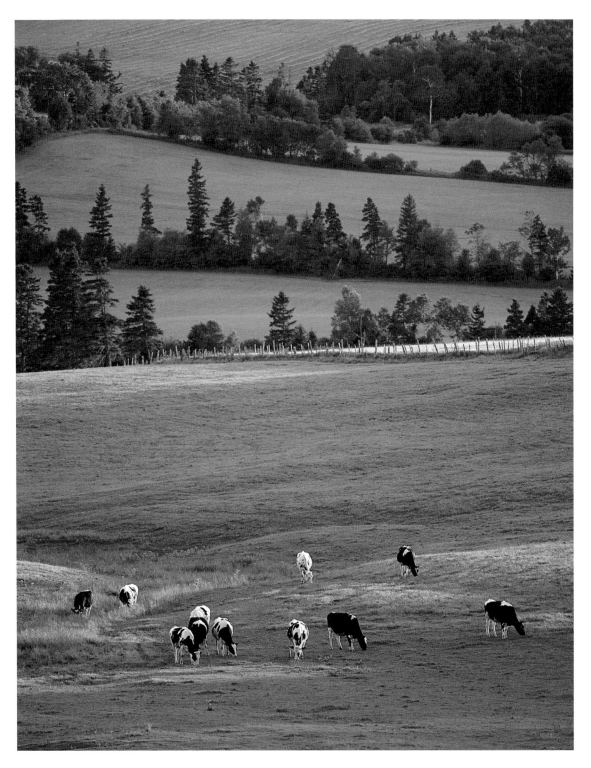

NEW GLASGOW. I HAD TRIED TO PHOTOGRAPH THESE YOUNG COWS ON SEVERAL OCCASIONS, BUT THE
CURIOUS ANIMALS ALWAYS GALLOPED OVER TO THE EDGE OF THE FIELD TO HAVE A CLOSER LOOK AT ME. THIS
TIME THEY WERE FARTHER AWAY SO I COULD PHOTOGRAPH THEM UNDETECTED WITH A TELEPHOTO LENS.

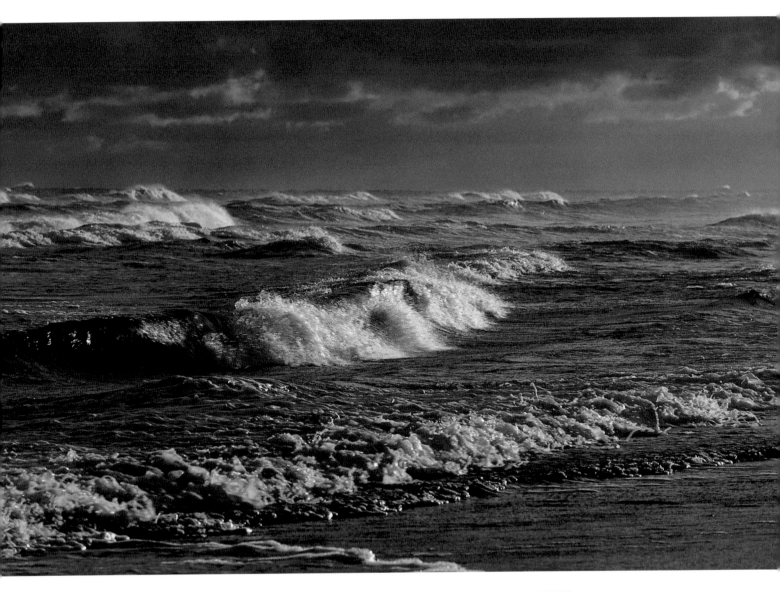

CAVENDISH. AN AUTUMN STORM BRINGS A THUNDERING SURF TO THE NORTH SHORE.

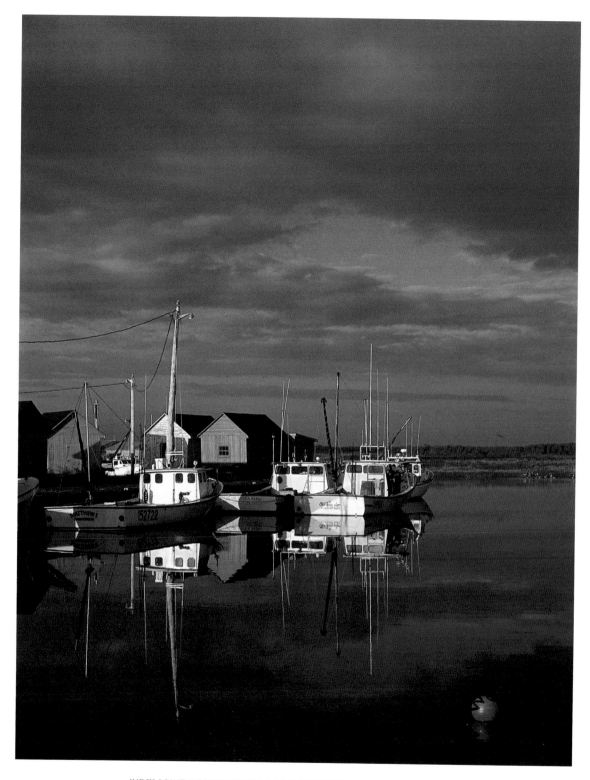

JUDE'S POINT. MORNING LIGHT ILLUMINATES THESE FISHING BOATS NEAR THE
ACADIAN COMMUNITY OF TIGNISH IN WESTERN PRINCE EDWARD ISLAND.

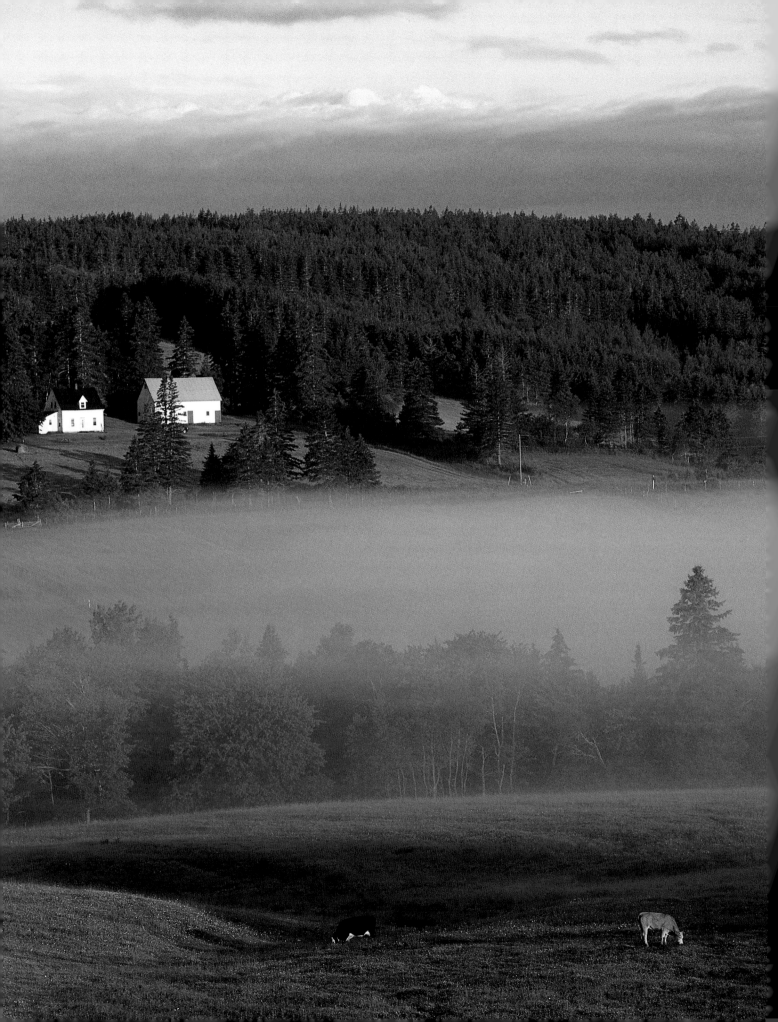

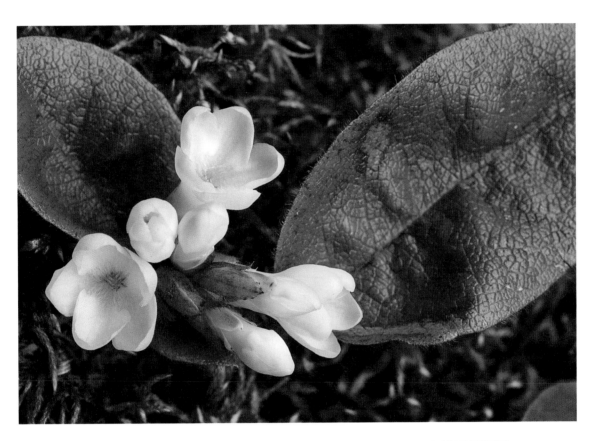

UNION ROAD. THE TINY MAYFLOWER—TRAILING ARBUTUS—CAN BE FOUND CLINGING LOW TO THE
GROUND IN WOODED AREAS NOT LONG AFTER THE LAST SNOWS HAVE MELTED. THESE WERE SHOWN TO ME BY
MY MOTHER-IN-LAW, WHO REMEMBERS PICKING MAYFLOWERS AT THIS SAME LOCATION WHEN SHE WAS A GIRL.

FACING PAGE: RIVERDALE. ON CALM SUMMER MORNINGS I USUALLY FIND A MIST
FLOATING ABOVE THIS BEAUTIFUL VALLEY IN CENTRAL QUEEN'S COUNTY.

OVERLEAF: MURRAY RIVER. EVENING SUN HIGHLIGHTS THESE BOATS AGAINST THE TREE-LINED SHORES OF MURRAY RIVER.
THE BOATS ARE USED IN THE MUSSEL INDUSTRY THAT THRIVES IN THE FERTILE BAYS AND ESTUARIES OF THE ISLAND.

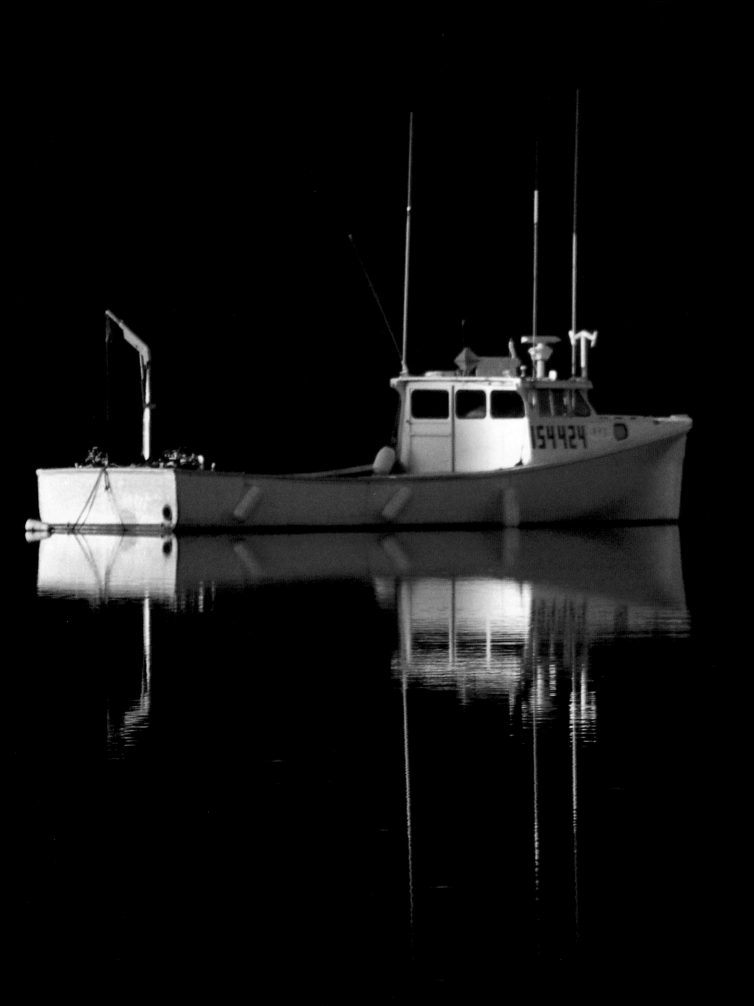

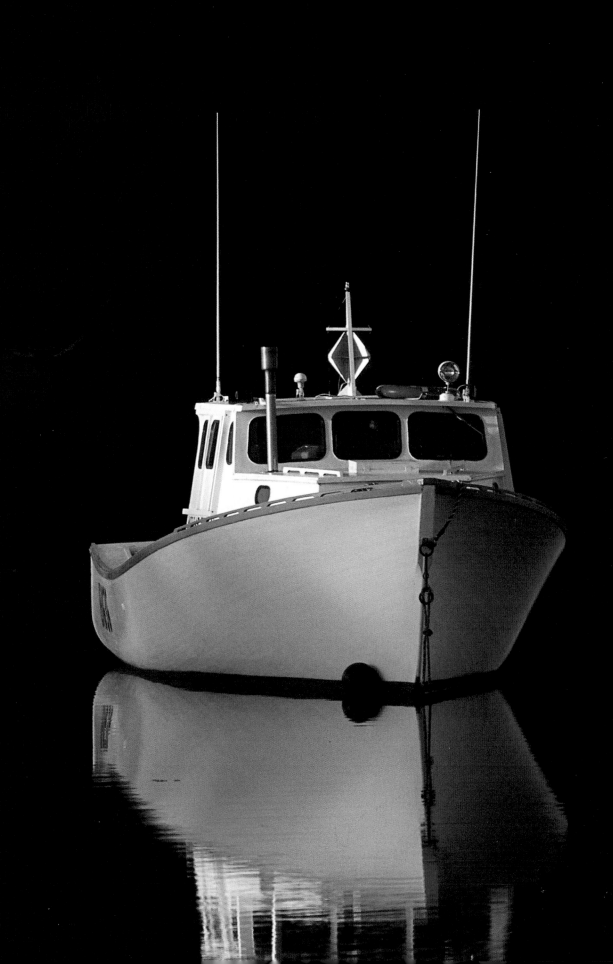

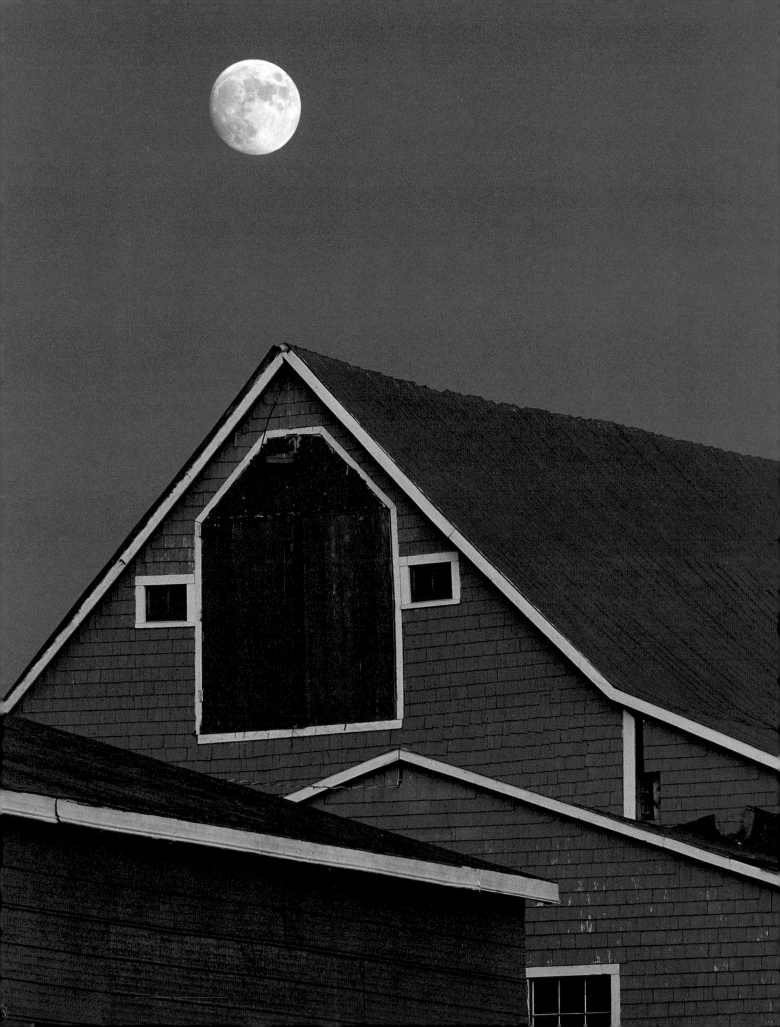

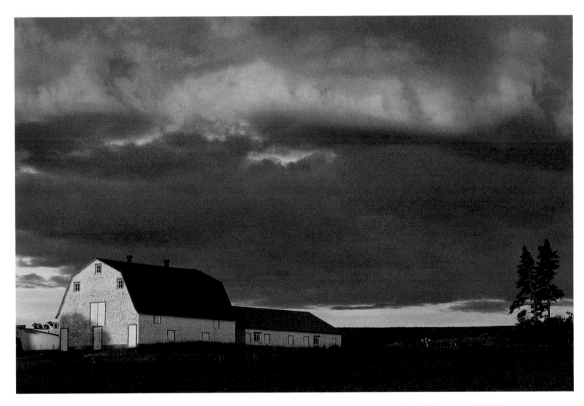

FRENCH RIVER. WHILE ON MY WAY TO PHOTOGRAPH SUNRISE ON THE NORTH SHORE, I WAS STOPPED
SHORT BY THE COLOUR AND DRAMA OF THE SKY. WHEN THE SUN BROKE THROUGH THE CLOUDS TO
ILLUMINATE THE BARN, THE IMAGE WAS COMPLETE. (I NEVER DID GET TO THE SHORE!)

FACING PAGE: NEW GLASGOW. AN ALMOST FULL MOON RISES OVER A HAY BARN ON A CLEAR SUMMER EVENING.

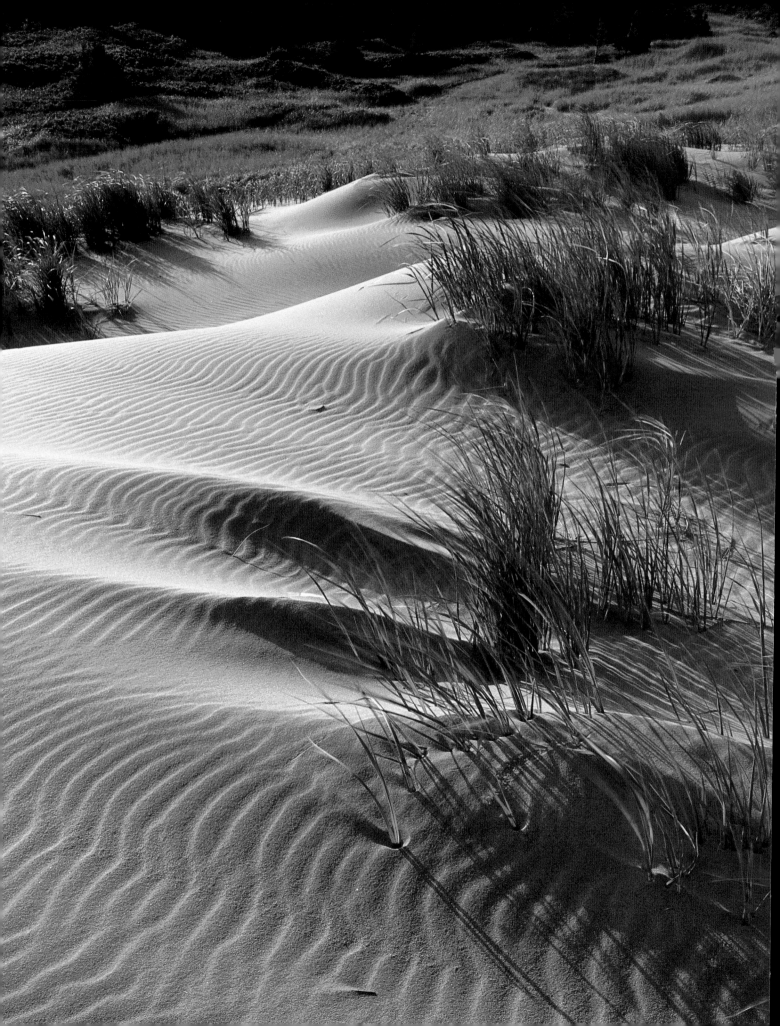

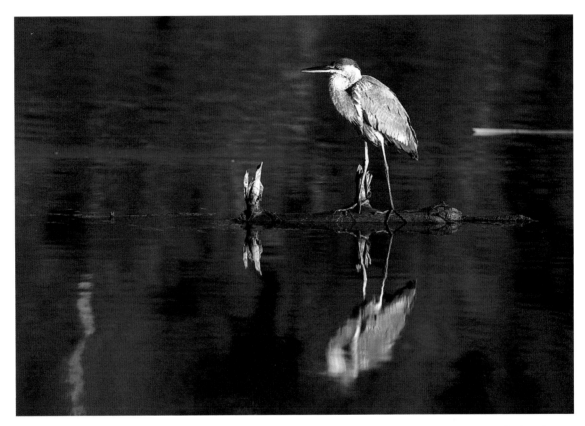

NEW GLASGOW. THE GREAT BLUE HERON IS A COMMON SIGHT ALONG THE ISLAND'S RIVERS AND ESTUARIES. I'M OFTEN
FRUSTRATED IN MY ATTEMPTS TO PHOTOGRAPH THEM BECAUSE THEY ARE SO WARY. ON THIS OCCASION I WAS ABLE TO GET
CLOSE TO THE RIVER'S EDGE IN MY CAR, USING IT AS A BLIND.

FACING PAGE: GREENWICH. WITH ITS TALL AND DRAMATIC SAND DUNES, THE TIP OF THE GREENWICH PENINSULA
IS THE ISLAND'S MOST UNIQUE NATURAL ENVIRONMENT. IT WAS BROUGHT UNDER THE PROTECTION OF
PRINCE EDWARD ISLAND NATIONAL PARK IN 1998.

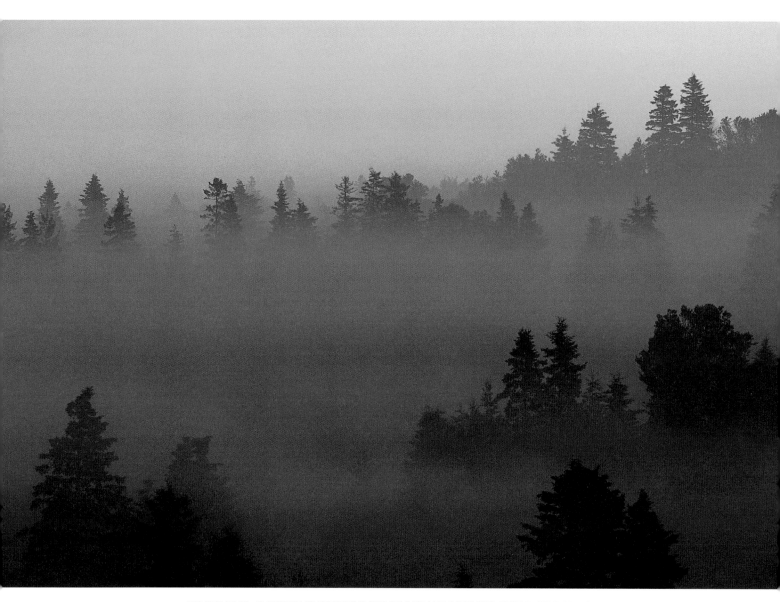

HUNTER RIVER. AT CERTAIN TIMES DURING THE SUMMER AND EARLY FALL, HEAVY MORNING MIST
CLOAKS THE HILLS NEAR MY HOME. I HAVE MANY IMAGES OF SUN STREAMING THROUGH THE TREES,
BUT I PREFER THE PASTEL TONES PRODUCED BY THE PREDAWN LIGHT IN THIS IMAGE.

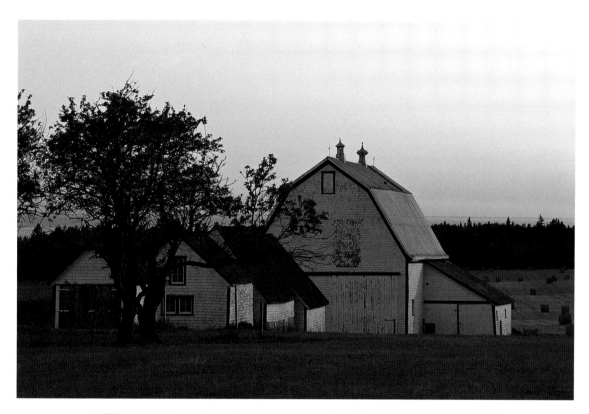

BORDEN-CARLETON. AN OLD GAMBREL-ROOFED BARN REFLECTS THE WARM LIGHT OF SUNSET ON
A FARM OVERLOOKING NORTHUMBERLAND STRAIT ON THE ISLAND'S SOUTH SHORE.

OVERLEAF: SPRINGBROOK. I HAVE PHOTOGRAPHED THIS HOUSE MANY TIMES OVER THE YEARS, WITH DIFFERENT CROPS GROWING
IN THE FRONT FIELD—HAY, GRAIN, OR, IN THIS CASE, POTATOES. I'M ALWAYS EXCITED IN THE SPRING TO SEE WHAT'S GROWING THERE.

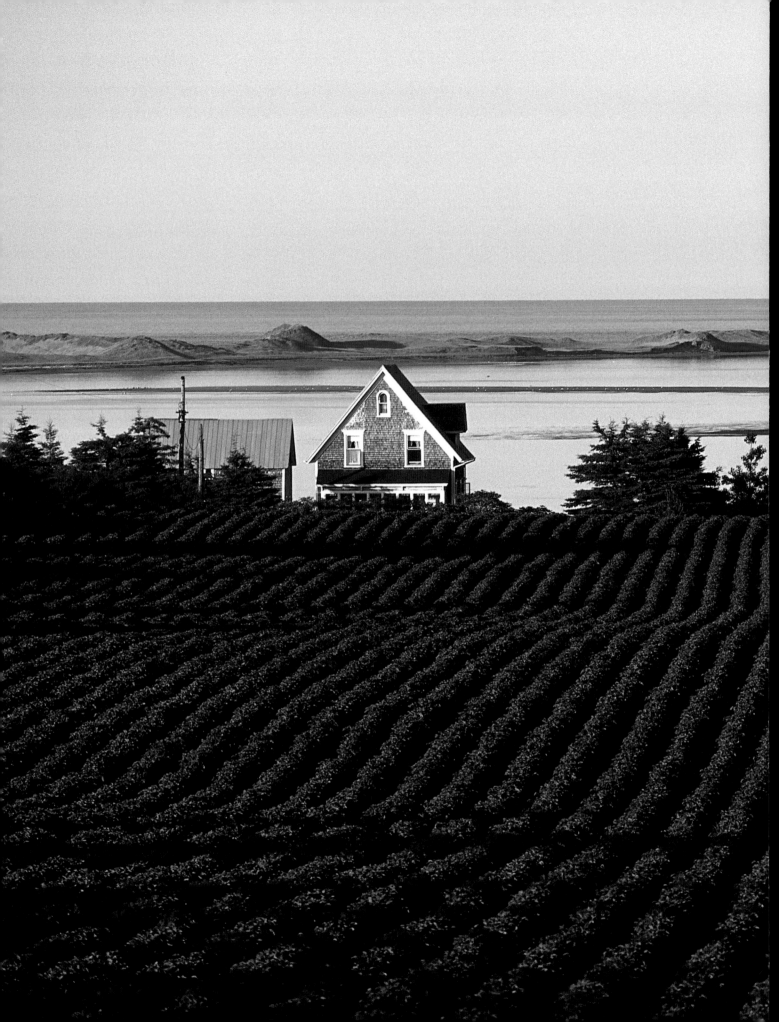

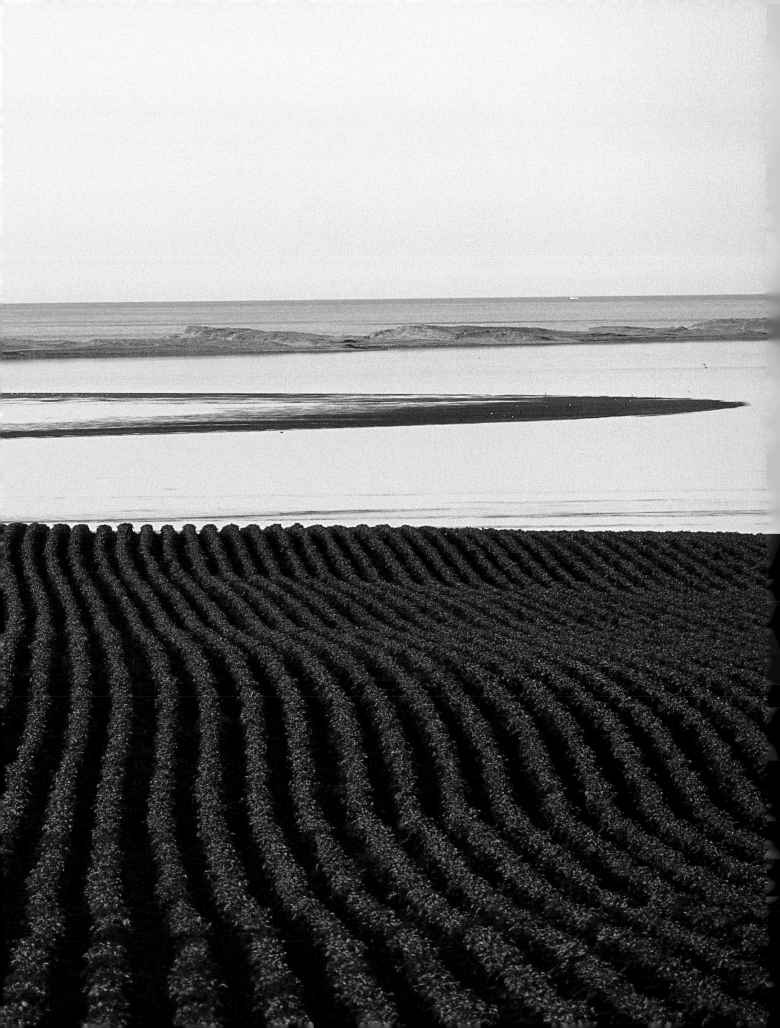

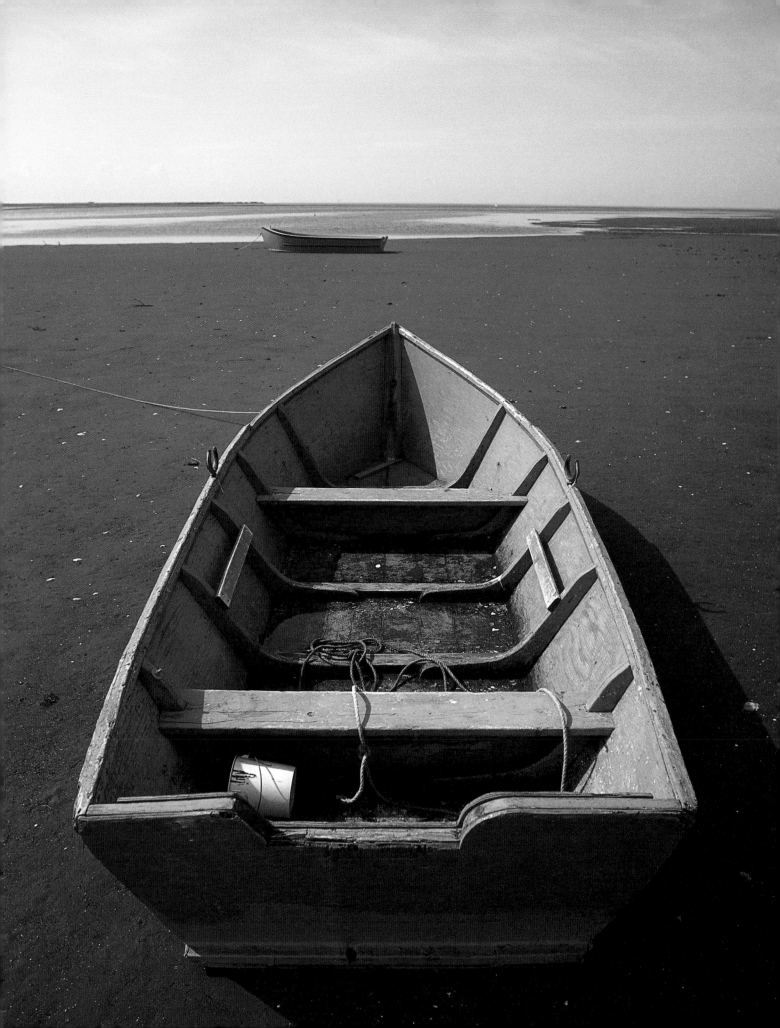

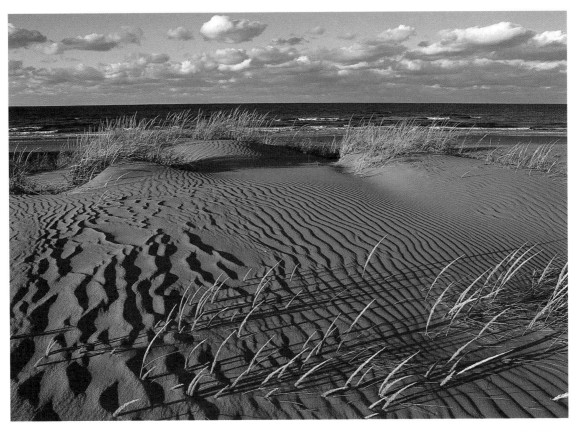

BRACKLEY BEACH, PRINCE EDWARD ISLAND NATIONAL PARK. SEPTEMBER IS MY FAVOURITE TIME TO PHOTOGRAPH THE ISLAND'S SPECTACULAR SAND DUNES. AUTUMN WINDS HAVE SWEPT AWAY ALL TRACES OF SUMMER FOOTPRINTS AND RETURNED THIS ENVIRONMENT TO ITS WILD AND PRISTINE STATE.

FACING PAGE: ABRAM VILLAGE. LOW TIDE LEAVES TWO DORIES HIGH AND DRY ON THE SANDS OF THIS SOUTH SHORE BEACH.

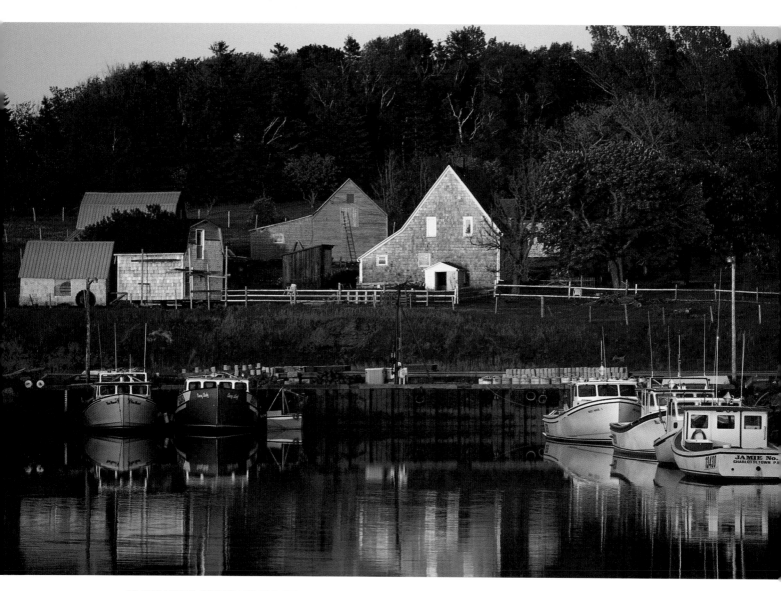

STANLEY BRIDGE. STANLEY BRIDGE BASKS IN THE GLOW OF A SUMMER EVENING. THE TINY VILLAGE, WHICH DATES BACK TO THE MID-1800s, IS SITUATED AT THE MOUTH OF THE STANLEY RIVER WHERE IT EMPTIES INTO NEW LONDON BAY.

BEACH POINT. A TROPHY FROM A SUCCESSFUL FISHING TRIP ADORNS A FISH SHED. THIS TAIL COMES FROM
A GIANT BLUEFIN TUNA. WHICH IS HIGHLY SOUGHT AFTER IN THE WATERS OFF EASTERN PRINCE EDWARD ISLAND
DURING A FISHING SEASON THAT LASTS FROM AUGUST TO OCTOBER.

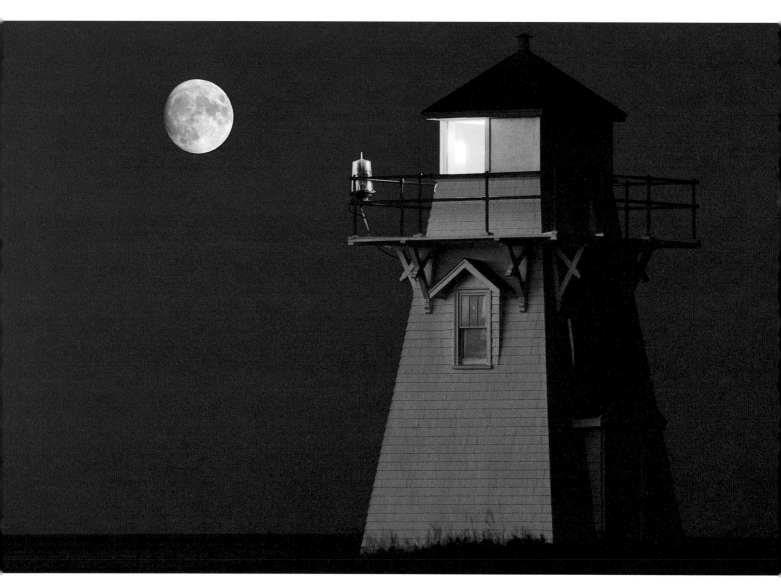

COVEHEAD LIGHTHOUSE. TWILIGHT IS REFLECTED ON THE SIDE OF THIS NORTH SHORE LIGHTHOUSE
AS AN ALMOST FULL MOON RISES IN THE EASTERN SKY.

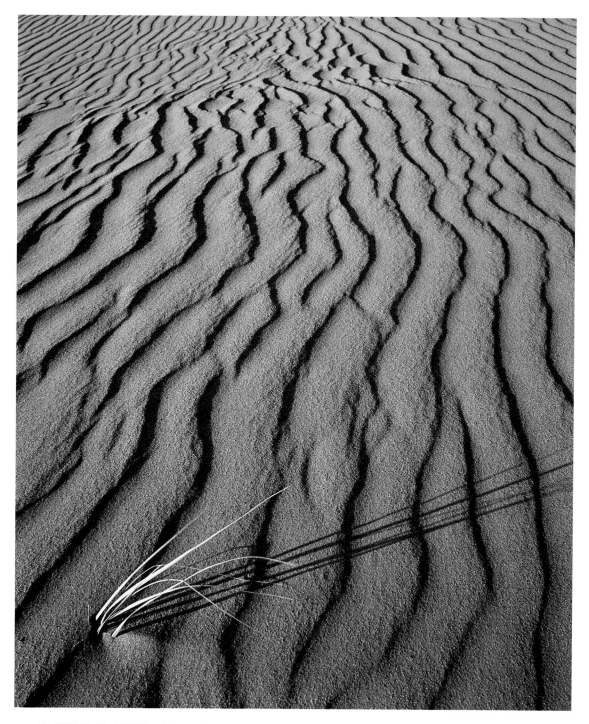

BRACKLEY BEACH. I COULD ALMOST IMAGINE I WAS IN THE DESERT AS I PHOTOGRAPHED THESE BLADES OF MARRAM GRASS
SURROUNDED BY WIND-SCULPTED SAND. BUT THE SOUND OF THE OCEAN A SHORT DISTANCE AWAY REMINDED ME OF WHERE I WAS.

OVERLEAF: CHEPSTOW POINT. I HAD ALWAYS PASSED THIS PLACE WITHOUT STOPPING TO PHOTOGRAPH. THEN A COUPLE
OF YEARS AGO THIS HOUSE APPEARED ON THE CLIFF EDGE, ADDING A COMPELLING FOCAL POINT TO THE SCENE.

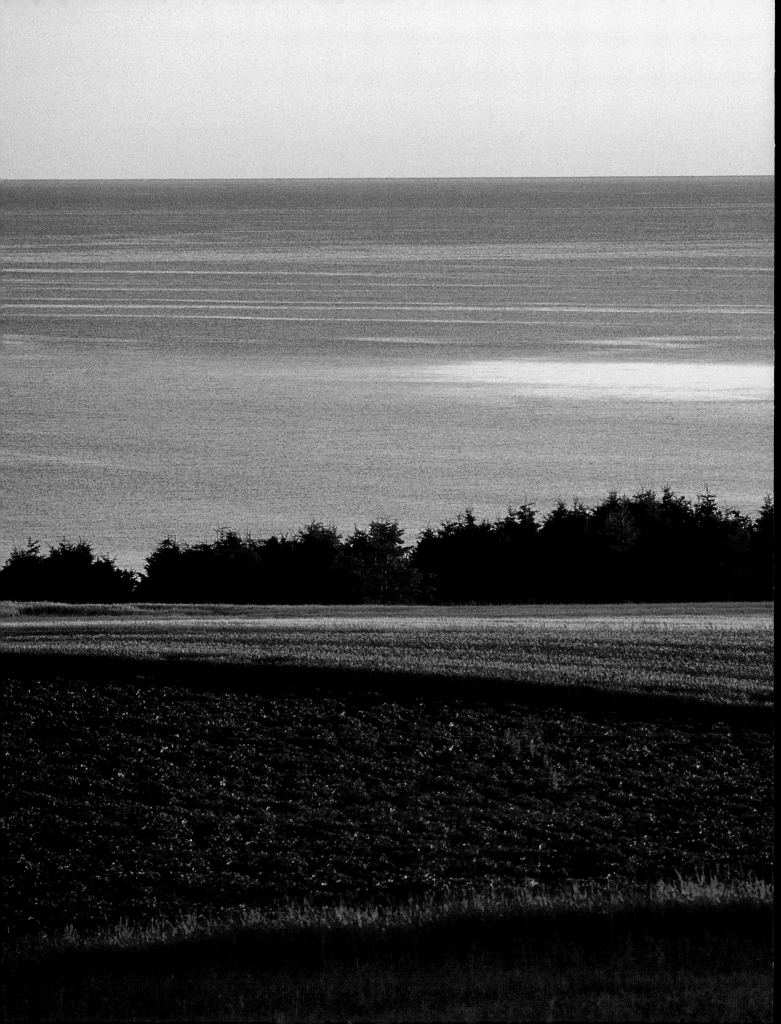

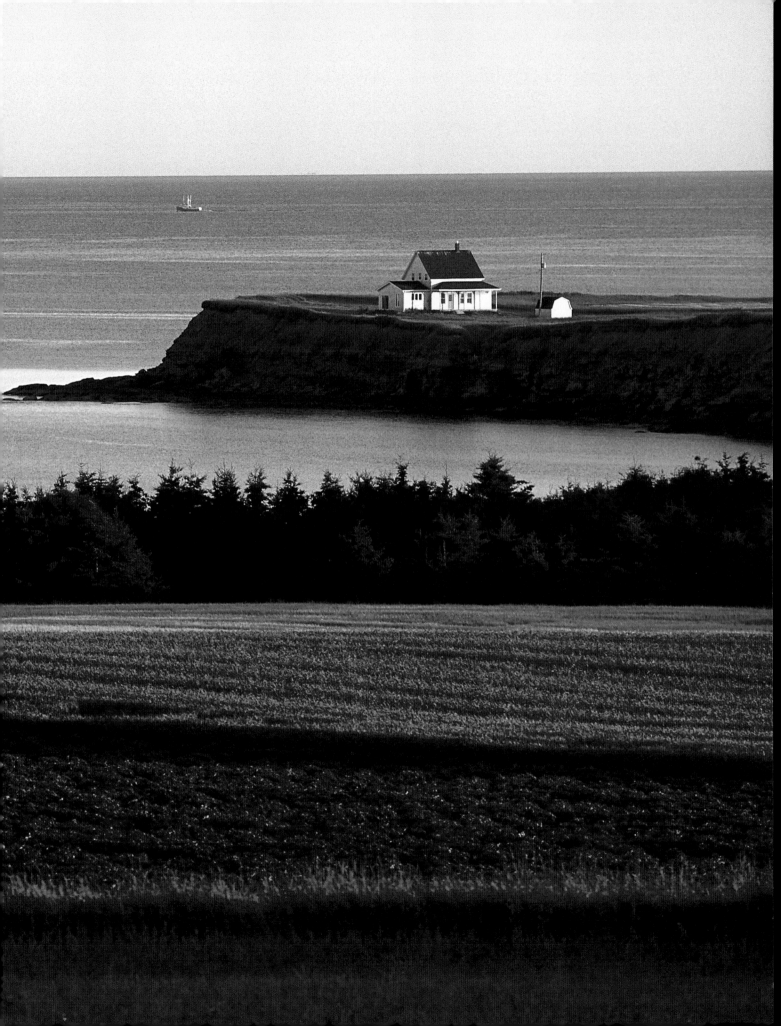

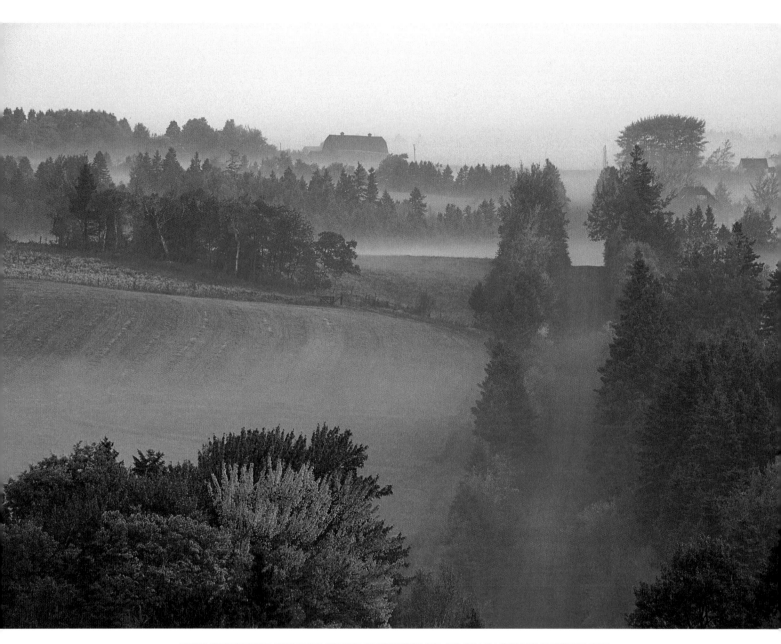

LITTLE BUNGAY ROAD, GREENVALE. SOMETIMES I DON'T TRAVEL FAR ON MY MORNING PHOTOGRAPHIC
EXCURSIONS. THIS IMAGE WAS MADE JUST A FEW STEPS FROM THE END OF MY DRIVEWAY.

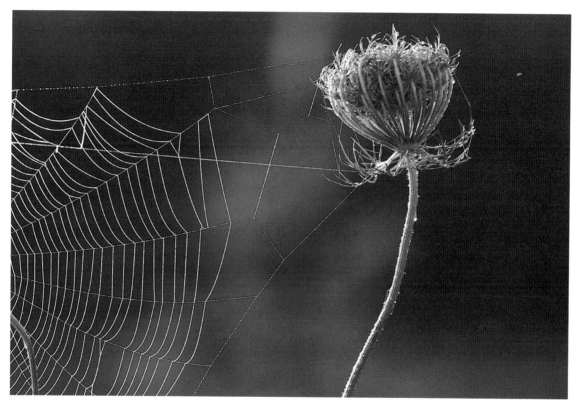

RENNIE'S ROAD. ON DEWY SEPTEMBER MORNINGS, OVERGROWN FIELDS AND ROADSIDE DITCHES ARE ADORNED WITH HUNDREDS OF SHIMMERING SPIDERS' WEBS. HERE THE STRANDS OF A WEB PULL AT A WITHERED FLOWER OF QUEEN ANNE'S LACE.

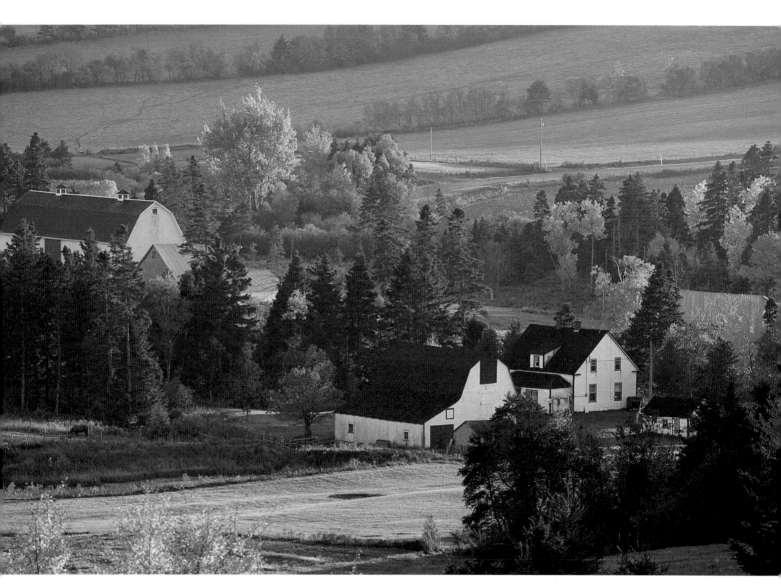

NEW GLASGOW. THE RURAL LANDSCAPE IS SLOWLY CHANGING WITH THE DISAPPEARANCE OF
SMALL FAMILY FARMS. REMARKABLY, THE PICTURESQUE FARMSTEADS IN THIS SCENE HAVE REMAINED
ALMOST THE SAME AS WHEN I FIRST PHOTOGRAPHED THEM NEARLY TWENTY YEARS AGO.

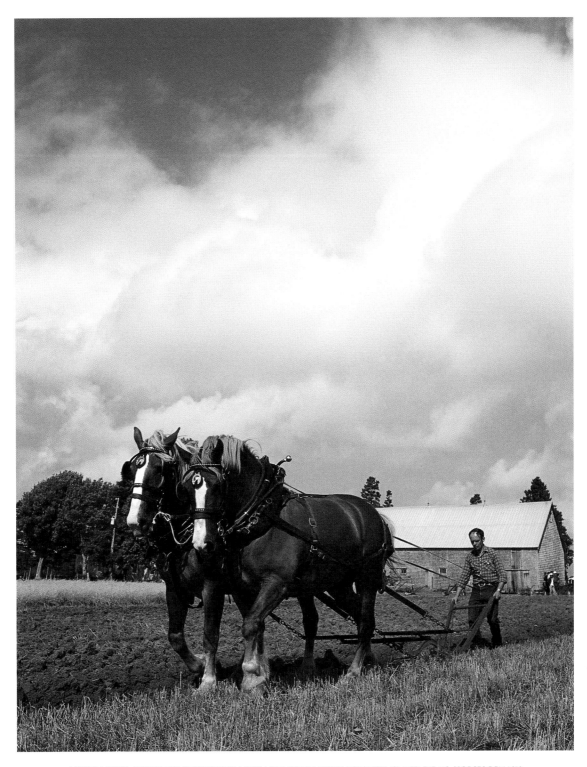

LITTLE SANDS. ALTHOUGH THEY'VE BEEN REPLACED BY TRACTORS ON MOST ISLAND FARMS, HORSES REMAIN
VERY POPULAR. AT THE ANNUAL DRAFT HORSE FIELD DAY YOU CAN WATCH THESE MAGNIFICENT ANIMALS
PULLING PLOWS, MOWERS, AND BINDERS, AND IMAGINE RURAL LIFE IN A SIMPLER TIME.

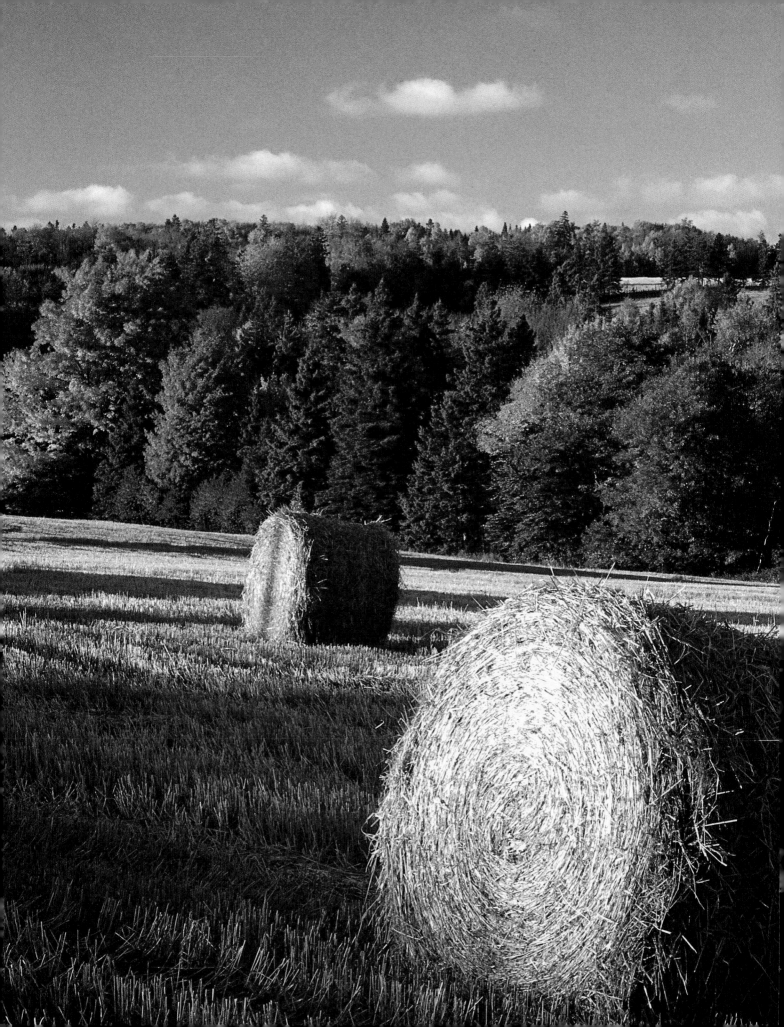

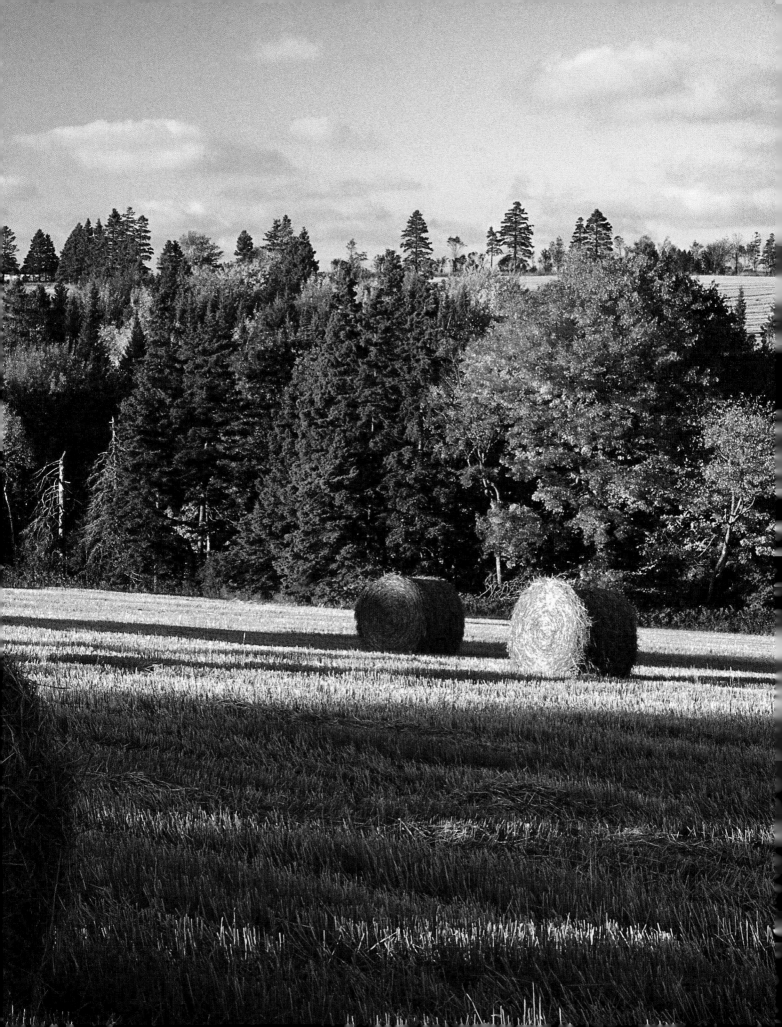

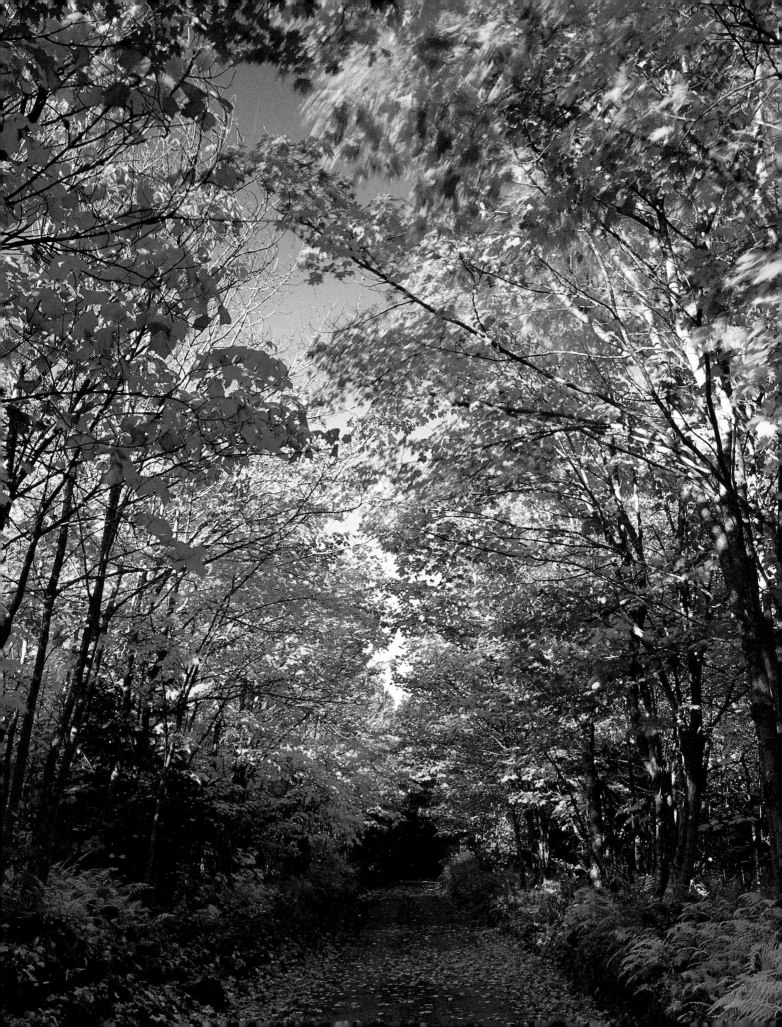

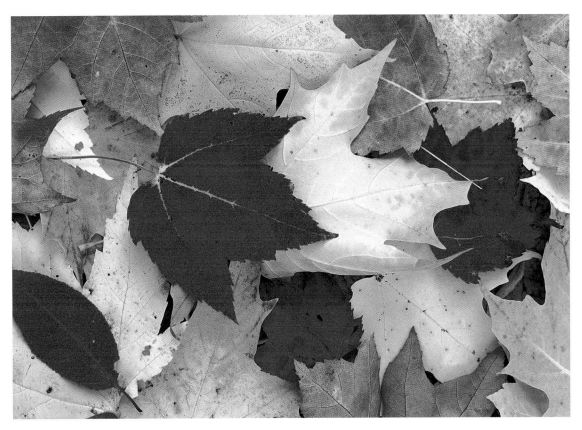

SOUTH GRANVILLE. A DETAIL FROM A COLOURFUL TAPESTRY OF LEAVES SCATTERED ALONG THE OLD TOWN ROAD.

FACING PAGE: MCCOURT ROAD, SOUTH GRANVILLE. NO AUTUMN IS COMPLETE UNLESS I HAVE PHOTOGRAPHED
A TUNNEL OF COLOUR ALONG ONE OF THE ISLAND'S MANY OLD CLAY ROADS.

PREVIOUS PAGE: WHEATLEY RIVER. STRAW BALES AWAIT TRANSPORTATION TO A NEARBY FARM WHERE
THE STRAW WILL BE USED AS ANIMAL BEDDING DURING THE WINTER MONTHS.

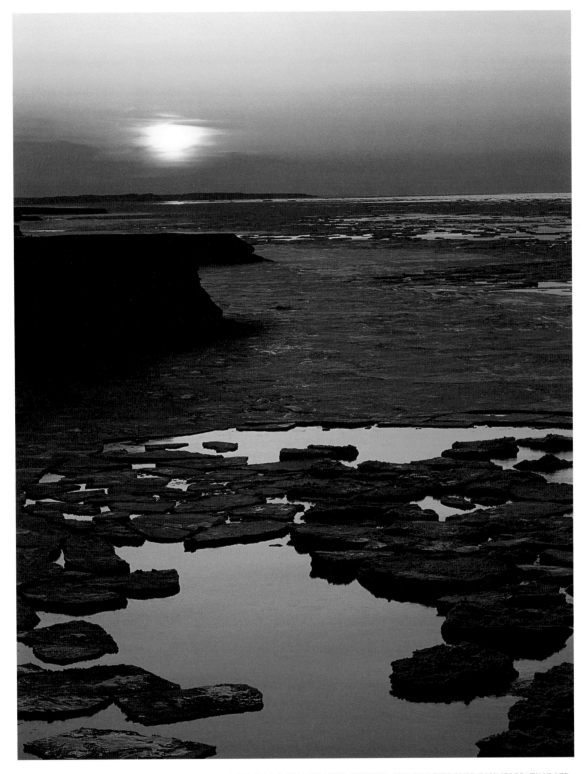

ORBY HEAD. PRINCE EDWARD ISLAND NATIONAL PARK. ON A CALM MID-APRIL EVENING, THE SUN SETS OVER DISINTEGRATING ICE IN THE GULF OF ST. LAWRENCE. SEA ICE HOLDS THE ISLAND IN A WINTRY GRIP WELL INTO SPRING.

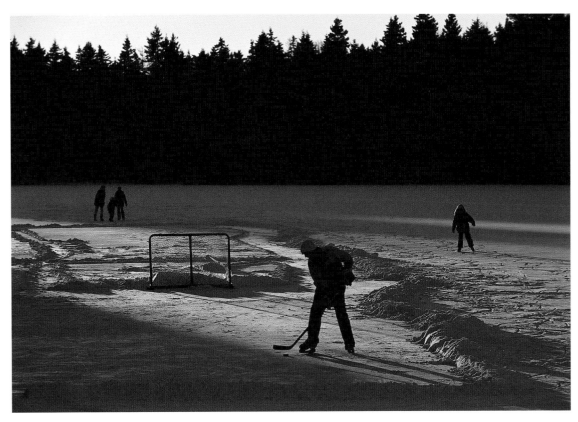

KNOX'S DAM. SKATERS AND HOCKEY PLAYERS TAKE TO THE ICE OF THE FROZEN MONTAGUE RIVER IN A TIMELESS WINTER SCENE.

OVERLEAF: NORTH WILTSHIRE. THE PALE LIGHT OF A MID-WINTER MORNING DRIFTS ACROSS
A LANDSCAPE AT REST UNDER A BLANKET OF NEW-FALLEN SNOW.

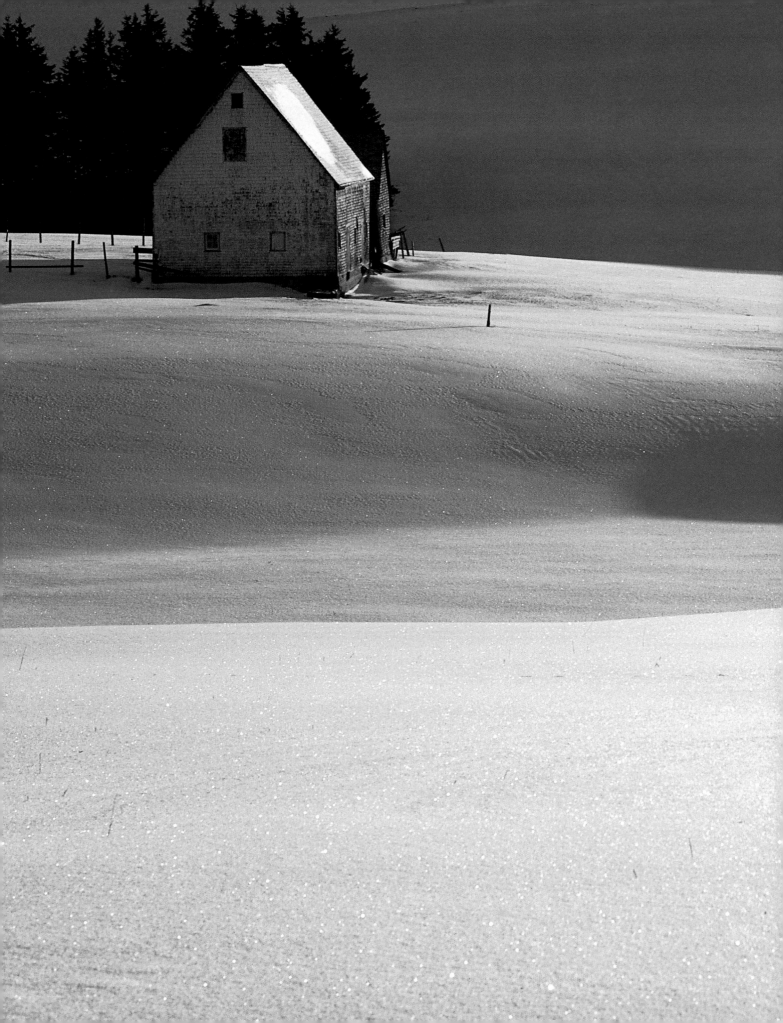

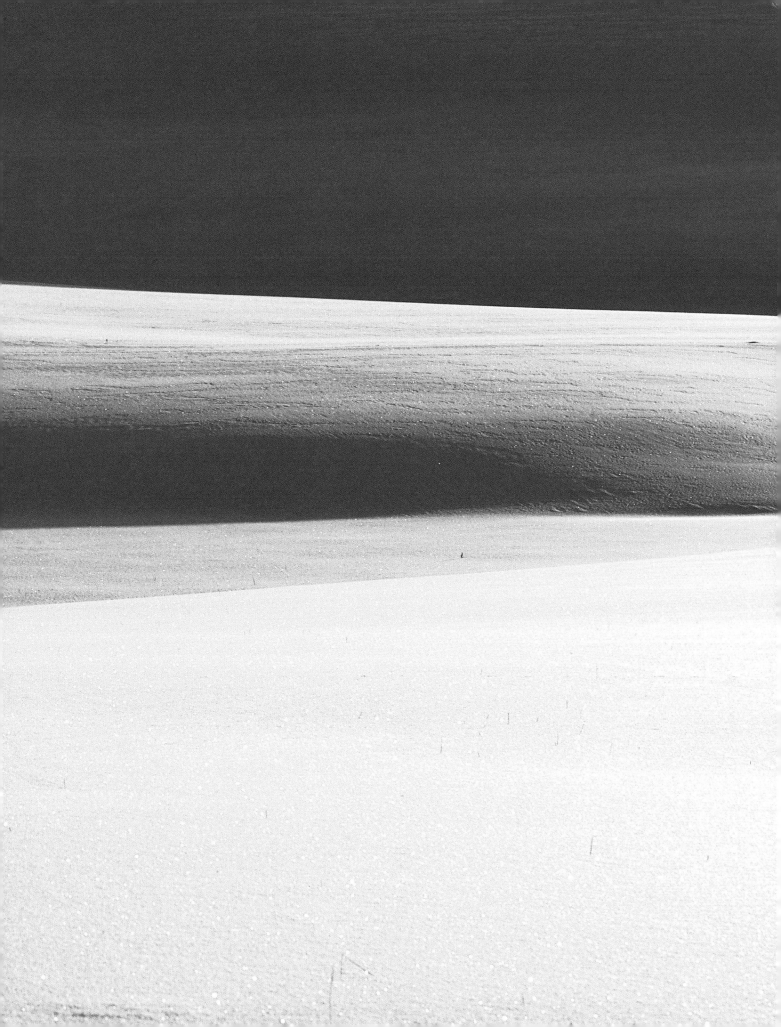

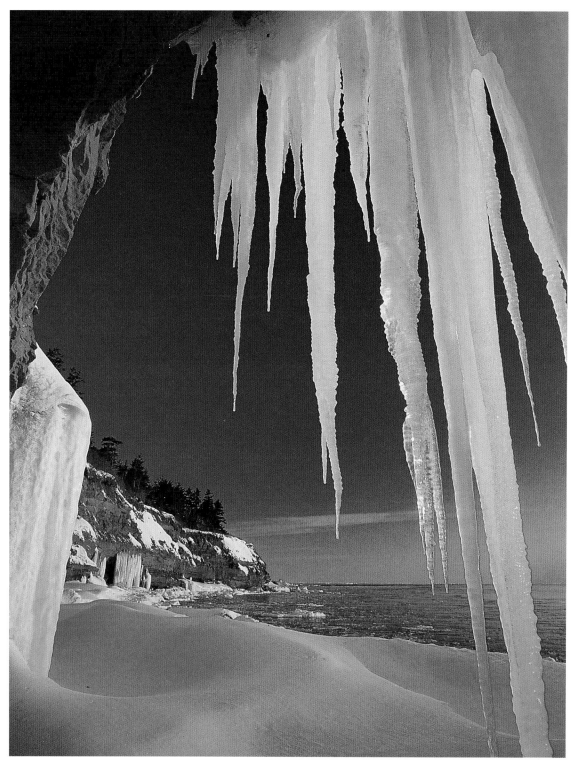

CAPE TURNER, PRINCE EDWARD ISLAND NATIONAL PARK. MASSIVE ICICLES, AGLOW AT SUNRISE, ARE FORMED FROM SPRING WATER THAT STREAMS DOWN THESE CLIFFS YEAR ROUND.